SOUTH CAROLINA
COUNTRY ROADS

SOUTH CAROLINA COUNTRY ROADS

OF TRAIN DEPOTS, FILLING STATIONS & OTHER VANISHING CHARMS

For Shirlee,
Happy Birthday!
Tom Poland
May 18, 2018

TOM POLAND

Foreword by Aïda Rogers

THE
History
PRESS

Published by The History Press
Charleston, SC
www.historypress.net

First published 2018

Manufactured in the United States

ISBN 9781467138864

Library of Congress Control Number: 2017963233

CONTENTS

CONTENTS

A CERTAIN EYE

I T TAKES A CERTAIN EYE to see beauty in the abandoned, the collapsing, the forgotten. But Tom Poland has that eye, as well as a camera to document these things before they're gone for good. He also has the curiosity to find out what these monuments to life and land once were. Who came to this general store with the roof falling in? Why are cemeteries surrounded by cedars? What makes these heirloom tomatoes heirloom?

The truth is, everything Tom has given us in this book is an heirloom, whether it's a rusting iron bridge you can no longer cross or a 1940s gas pump long gone dry. Even winter's dreamiest camellias—blooming in genteel competition in history-soaked Edgefield—are fodder for his eye and mind. Consider Tom a triple threat on the page: he researches, he photographs and he tells us things we never knew. And Lord, can he write. I suggest succumbing to your comfiest chair with your favorite beverage— TV off—to wallow in his words. Pick a chapter, any chapter, and read out loud. It's clear the back roads of South Carolina have captivated this visual and literary artist.

Tom would probably dispute those words, but artist he is. He may call himself an explorer, a time traveler, a "blue-collar historian"—and he is all those things—but the man has a gift he's been lavishing on readers since 1978, four years after he crossed the Savannah from Lincolnton, Georgia, to make South Carolina his home.

Friends, we are richer for his move. In these pages, he takes us places we've been too lazy or blinded to see, too world-frazzled and work-focused to go.

How many times have you seen a side road with a strange name and wanted to turn, go down it, see what's there? How many times did you say not now, no time, I'll come back—only you forgot until you passed that way again? And then you repeated the whole aggravating thing?

South Carolina Country Roads might trigger you to finally take that turn, divert you from your routine, breathe some new air. It might prompt you to stop at that store that always got your attention, talk to that friendly person behind the counter, learn you have things in common—maybe even people in common. It might even inspire you to write your own story, take your own photos and—here's the kicker—give them to someone who will treasure them.

That's what Tom has done with this book. He's collected South Carolina's crumbling treasures and put them in one place for our posterity, giving them context and honor. It's a sad truth that memories die with the people who hold them. This book fights that reality. So does its beautiful language. Sink into this passage from "A Train Rolls through It," about Tom's sojourn in Branchville: "Percussive clacking and airy weeping goes the night train anthem—how mournful in the dead of night, how lonely to those in blackened countryside lying in beds. Perhaps a few envy the travelers piercing their night. 'To what magical places do they go?'"

It's Tom Poland who's making the magic. He's unlocked an invisible door into a world many of us in cities and suburbs rarely see. And this world, this place called Obscurity, is even more fascinating because it exists right alongside us. At least for now.

Aïda Rogers
Columbia, South Carolina
August 2017

THE ROAD LESS TRAVELED

E VER STOP TO THINK how much time you spend on the road? Statistics say the average American spends three hours a day in a car. I used to drive I-20 a lot. It was like traveling across a desert. Not much to see. Nor that pleasant. Seems more and more big trucks barrel down the interstates. You eat up a lot of gas speeding along beside them. More often than not, the roads are rough and noisy. Can't even hear your radio. Hard on the nerves.

Make a change.

Robert Frost urged us to "take the road less traveled," for the lesser-traveled road tells a story. Miles become pages, trips become chapters and a tale unfolds. In fact, a road has a story to tell. Most roads owe their existence to ancient animals whose paths evolved into Indian trails. Drive to a nearby town and chances are you're following in the steps of ancient men who tracked game right where your wheels roll. You're traveling in time, making a journey.

Life is a journey, and as songs attest, a road provides a metaphor for life: "The Long and Winding Road"…"On the Road Again"…"Life Is a Highway"…and Robert Plant's "Big Log," a nod to the book in which tractor-trailer drivers log road hours.

Americans have long had a love affair with road trips. Jack Kerouac wrote *On the Road* based on road trips Kerouac and friends made across midcentury America. From 1960 to 1964, *Route 66* aired weekly over CBS. Two drifters in a Corvette on a cross-country odyssey encountered loners, dreamers and outcasts along U.S. Highway 66. William Least Heat-Moon wrote *Blue*

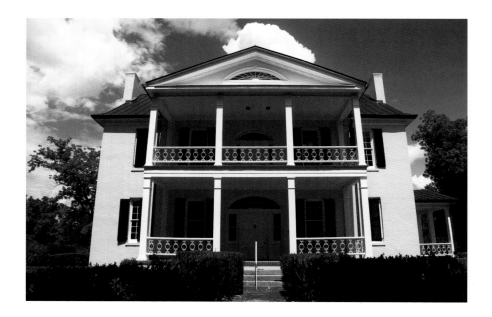

Highways: A Journey into America. Published in 1982, it chronicled his journey along the country's back roads.

We all can make a back road journey, and we should, for the pace slows along the back roads. When you travel a back road, your gas mileage goes up and your blood pressure goes down. Easy to stop when you feel like it. Open your windows and inhale the freshness of newly mown hay. Smell the fertile fragrance of rain pelting craters in a dusty dirt road. Listen to the melodic singing of the catbird. Discover Rose Hill, an old southern plantation. Visit the past a bit.

Take a lonely road and you won't be lonely long. Unforgettable sights will keep you company. Down Lowcountry way discover a classic setting: a tire swing hanging from a massive live oak and an old fire tower looming over a saltwater creek.

Look around and you'll behold a memorial to brave seamen who lost their lives working South Carolina's coastal waters.

Meet the people who live and work along secondary roads. Men and women who work with their hands. Men who forage grassy shoulders seeking fresh greens. Pull over to the side of a country road that edges a fishpond and see where boys encountered a bit of bad luck.

See abandonment. In the Lowcountry, down an allée of oaks, you'll find two-hundred-year-old tabby ruins of one of the South's most magnificent

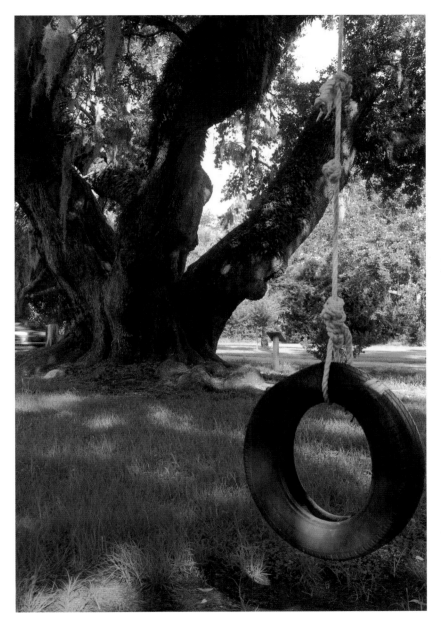

ABOVE A classic country scene. A tire swing hangs from Deehead Oak in McClellanville at, where else, Oak Street.

OPPOSITE Rose Hill Plantation, 2677 Sardis Road, Union. This backcountry road brings more than a glimpse of the antebellum South. William H. Gist, the secession governor, lived here.

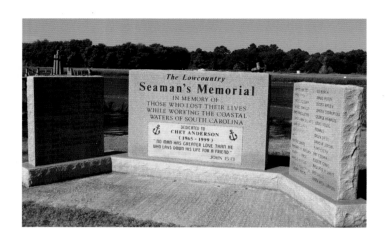

TOP A memorial to the men who perished working coastal waters. A reminder of the dangers of working on salt water. Near 405 Pinckney Street, McClellanville.

BOTTOM Near Mobley Oaks Lane on Spring Island, you'll see the remains of the main house of George Edwards, the richest man in South Carolina during the days when cotton was king.

OPPOSITE Down a sandy road, bad luck gives us a rural scene best described as "aw shucks" disappointment, a scene common wherever cane poles venture.

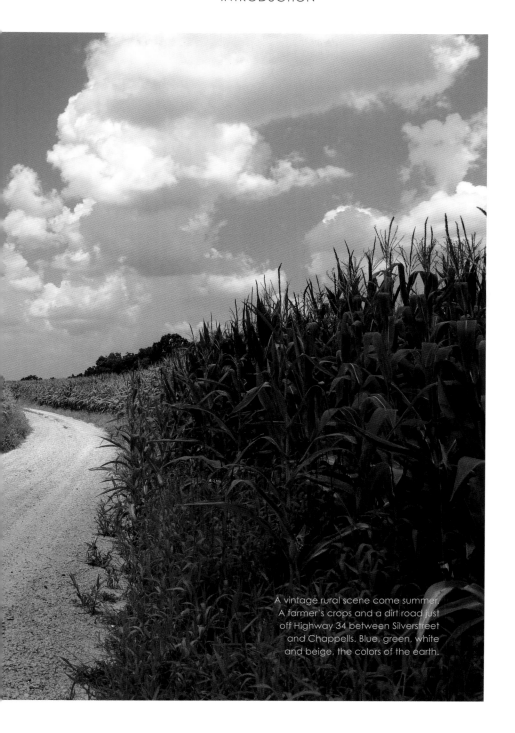

A vintage rural scene come summer. A farmer's crops and a dirt road just off Highway 34 between Silverstreet and Chappells. Blue, green, white and beige, the colors of the earth.

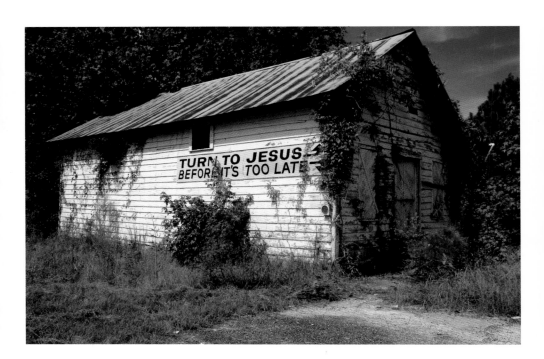

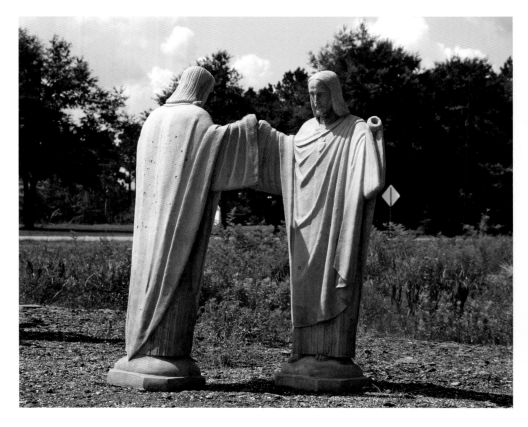

homes. Wonder about folks whose dreams died, killed by the devil Change. Take solace in the fact that you are driving where the hustle-and-bustle types dare not go.

Behold the land. Behold the South. A winding ribbon laid upon the face of the earth, obscure roads prove quaint. I remember seeing a car barreling down a dirt lane eons ago, a billowing wake of dust settling onto the purple-green leaves of silage. We pave every road we can now, and cars trailed by dusty contrails are a rarity.

I love an old, weedy back road more than a freshly topped highway with pure white stripes. The old roads have character. Remember the centerline of tar? Gone. James Dickey mentioned that centerline in *Deliverance*: "Around noon we turned off onto a blacktop state road, and from that onto a badly cracked and weedy concrete highway of the old days—the thirties as nearly as I could tell—with the old splattered tar centerline wavering onward."

And then there were the old crushed blue granite roads. The heat of a summer day loosened the tar, freeing pebbles to ding against the undercarriage while the gravel ahead glittered like a field of diamonds. As tires rolled through pools of tar, it sounded like duct tape ripping loose.

Best of all, I love lesser-traveled roads like Highways 45, 28, 23, 283, 215, 49 and 521. Highway 45 takes you to some Carolina bays, mysterious jewels of wild habitat—if you know where to look. Driving roads like these to some obscure place you'll glimpse sights that revive the past. Pleas on abandoned stores exhort you to turn to Jesus before it's too late, and you'll spot statues of victorious fist-bumping Jesuses. Quaint churches, too. Travel enough back roads and you may cross paths with "Big Sky Bill," Bill Fitzpatrick. He's driven more than thirty thousand miles documenting South Carolina's churches and sites in the National Register of Historic Places. Bill hits the back roads to "make South Carolina history easier to enjoy. That is what I do."

Wander enough and you will cross the Great Philadelphia Wagon Road, known as the Old Wagon Road. It entered the state around Rock Hill and ran to Augusta, Georgia. You'll find traces of it at Landsford Canal State Park, off back roads 327 and 690.

OPPOSITE TOP Highway 521. This building and its plea greet folks headed home from the beach. Perhaps the exhortation gets a receptive audience. Perhaps not.

OPPOSITE BOTTOM A hallelujah moment. Fist-bumping Jesuses. Old US 1 North beyond Camden.

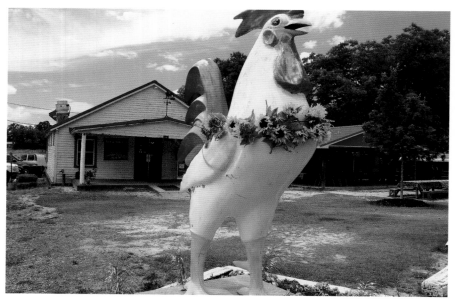

TOP On Highway 215 in Fairfield County, you can step into the past. You'll find this historic old store and a community frozen in time.

BOTTOM Northeast of Lake Secession at the intersection of Highways 284 and 185, you'll spy a huge rooster. Welcome to Grits & Groceries, real food, done real good in the middle of nowhere.

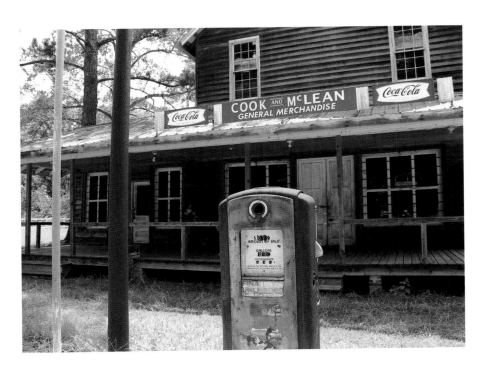

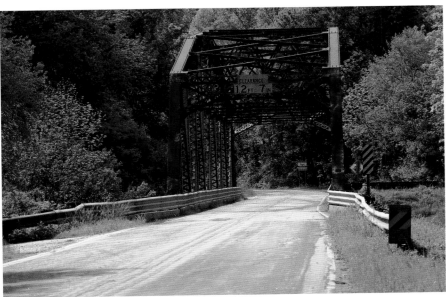

TOP Old stores with gas pumps out front are still out there, for now. You'll find this beauty off Nesmith Road in Williamsburg County, a ways from Little Hobcaw Plantation.

BOTTOM McCormick County, bridge to the past. Near Mount Carmel and the historic Calhoun Mill.

Keep wandering and you'll come across shuttered general stores, some of which referred to themselves as "mercantiles." Hungry? You'll discover jewels of restaurants, too—one with a big rooster towering over the parking lot at Saylors Crossroads.

A back road journey. It's like resurrecting your grandparents and visiting them once again. You'll discover the bones of the land, the DNA of real life.

So, just what is a back road? A typical dictionary entry might read something like this: "a little-used secondary road, especially one through a rural or sparsely populated area." I offer a more involved definition. It's a road that has no eighteen-wheelers on it. You can take your time. You won't find any fast food. You won't end up in a traffic jam, but you might find some strawberry jam. A bona fide back road will shower you with gifts: classic barns, country stores with old gas pumps and ruins and forsaken places. It'll cross a river upstream before it broadens, letting you see where that river calls home. You'll see abandoned tractors covered with vines. You'll drive past cemeteries where old cedars grow.

Come spring, you'll spot yellow-green clumps of daffodils signifying the presence of an old homeplace. Patches of blackberries along the shoulder will tempt you to hit the brakes. You'll drive past fading advertisements painted long ago by "wall dogs." You'll cross rusty, steel truss bridges into a land of beautiful wreckage and truck tires painted white overflowing with red geraniums. You'll catch a whiff of tantalizing smoke—pit-cooked barbecue. Sometimes it's a dead-end road where you hear a murder of crows on the attack and catch the sweet acidic scent of a bed of ants. Life in the country.

Catch sight of old homes like Williamsburg County's Thorntree, restored by those who value the past. The Pee Dee's oldest known residence, Irish immigrant James Witherspoon built Thorntree in 1749. A back road is a cultural paradise, an interstate a wasteland. Sure, driving an interstate saves time, but the downside is long stretches of nothingness. As Charles Kuralt pointed out, "The interstate highway system is a wonderful thing. It makes it possible to go from coast to coast without seeing anything or meeting anybody."

OPPOSITE TOP On SC Highway 527 near Kingstree, you can see a historic house, once in wilderness, but adapted to the New World, though with refinements from the Old World's good life.

OPPOSITE BOTTOM Near Monticello off Highway 215, you'll see an old homestead complete with outbuildings, a throwback to when a home had a smokehouse, henhouse, fruit trees and other necessities.

Now and then, I remind myself that driving itself is remarkable. In fact, it's astounding. You're rolling across the surface of a planet. You are a wayfarer, an explorer in your own planetary rover with a passport to adventure. Your best bet? Back roads. For somewhere down a road few consider, you'll find a place called Obscurity, where old homeplaces linger. It'll put you back in touch with your roots. And do so in a beautiful way.

WRECKAGE ALONG
THE BACK ROADS

I seek beautiful wreckage along the back roads. It's out there, a chest of tarnished treasure. The key is that red, white and blue shield. I know it is a place to avoid. Rather than speed from one destination to another, I follow old roads into the past. And it is there that I ramble, detouring and losing track of time. It's there that mysteries occur to me, something that never happens on a rough-surfaced interstate where road noise drowns out your thoughts.

On Highway 97 near Great Falls, you'll see the remains of an old store. Being between the forks of two roads did not save it. When the interstate came through, it sucked the life out of it and many more a business, a sad tale oft repeated. Not even the old tree it cradled survived. The stop sign appeared to be begging someone to stop at the old store, so I did.

I did not venture on to I-77. I stayed the course on Highway 97. With good reason. I speak to groups about my journeys into the countryside. I promise people that they will see nothing of interest along the interstates. You can be in Georgia, South Carolina or North Carolina and the terrain will be remarkably similar, mountainous regions excluded. The Land of Monotony's endless ribbons of asphalt and concrete make for a bland, sleep-inducing trip, albeit at timesaving speed. Think about that. Sleep inducing and high speeds. And gridlock, which you won't suffer on back roads.

I seldom travel interstates, only in dire circumstances—when no time to linger exists and when they can't be avoided. Whenever possible, I look at maps and plot alternate routes through the country. One Sunday, I got up

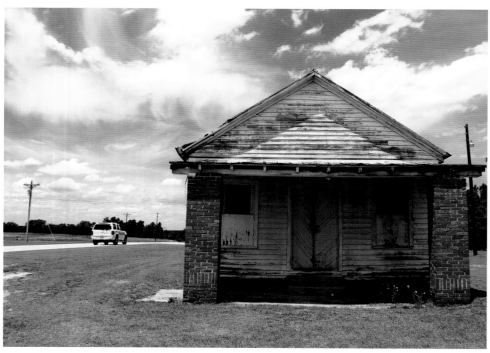

at five o'clock and hit the road for Davidson, North Carolina, to watch my granddaughter, Katie, play in a volleyball tournament. I could have slept in 'til 8:00 a.m., hit I-26 to I-20 and then to I-77 and made the trip in two hours. Instead, I took Highway 321 as far as I could before the interstate system got me in its clutches north of Charlotte. My journey took three and a half hours, but it was a great Sunday drive—well worth it.

I drifted through patches of fog and drove over corridors of billowing clouds called rivers and past streamers of mists that hung over ponds and lakes. Wildlife appeared out of the mists like phantoms. A wild turkey crossed the road in front of me. Later, two deer grazed along the shoulder only to spring up a shoulder into an avenue of oaks as I approached. A hawk perched on a powerline. A mockingbird chased a crow across a field (why the crow didn't turn and attack the much-smaller bird is something I cannot comprehend; some law of nature must be at work).

I saw quaint churches up close. Morning sunlight struck the white clapboard front of one with such force it blinded me, as if Jesus himself had just descended. Not far past there I saw an abandoned cemetery in a clearing, several stones leaning as if about to fall. I saw plenty of old homes, way too many adrift in weeds and vines. No one calls them home anymore, another mystery that confounds me.

Along back roads, pay attention to old churches, stores and homeplaces and you'll spot old-fashioned petunias. They bloom spring through autumn in muted pastel shades of pink, lavender and white, and unlike modern petunias, they're fragrant.

Sometimes a hitchhiker joins you, a funereal air attending him. Back roads can be melancholy places for wayfarers, for there they enter the resting place of dreams. "Boulevard of Broken Dreams" comes to mind. I see many businesses that went bust—gas stations, tire stores, hair salons and many an ill-fated nightclub. Along Highway 321, in the middle of nowhere, I passed a cinder block structure with a faded sign, its ghostly blue letters paling white. "Nite Life."

"Nite Death."

OPPOSITE TOP Highway 97. An abandoned store crumbles within sight of an interstate sign. Customers went one way, the store another.

OPPOSITE BOTTOM Old US 1 north of Aiken a ways. See the old petunias just to the left of the column on the right? See, too, the baseball next to the steps.

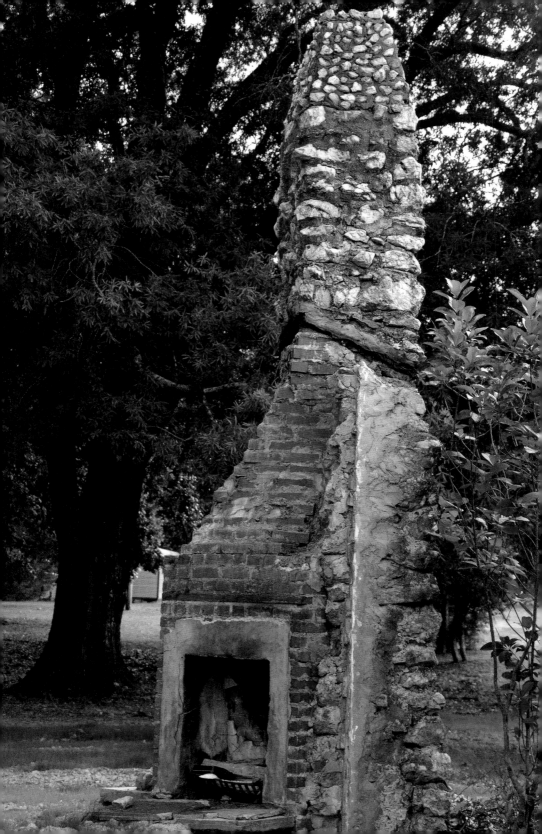

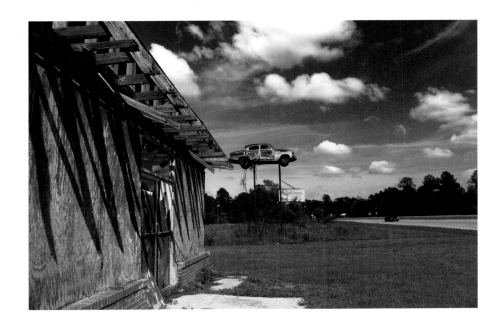

You get the feeling that a lot of these business owners had little money to start with. What became of them? Picked up and moved on, I suppose. But the beautiful, sad detritus aside, I love forgotten byways, sleepy lanes, gravel-dinging roads and dusty roads where the residue of the past clings to a slender thread called existence. Here you enter the province of historical markers, rusty steel bridges, hand-lettered signs, old gas pumps, tin shops, old sheds and fields rife with big round bales of hay.

Old stores, especially, catch my eye. Look closely at an old store's screen door and you just might spot a rusty sign—"Colonial Is Good Bread." Peek inside and you'll see an authentic bead board ceiling. Stores with locks on their doors and stores with broken windows share one thing: abandonment.

You'll also come across burned homes. Sometimes only chimneys remain, but delicious and colorful sights balance out dark moments. Come summertime you'll spot glistening blackberries or get a close look at a peach orchard and maybe come across heirloom tomatoes. You'll see poles hung with white gourds imploring purple martins to nest. And how about old cars stuck on poles as car shop advertisements.

ABOVE At the junction of Highways 176 and 301, an old car rides through the clouds.

OPPOSITE Near the junction of Highway 283 and 25 out of Edgefield, this beautiful old chimney stands as a monument to the home it once warmed.

Driving in the country seems more natural, and for sure it's more entertaining. Friendly fellows raise a finger from the steering wheel—"Hello." I like country folk. I sprang from their stock. I feel at home around them. Always worth a smile are the murals some local artist paints on the side of a store or shed. I saw one in a rural county on a cement block building… "Murals by Myra." What became of Myra and her murals? Mysteries abound on the back roads. About the only mystery you'll encounter on an interstate is an empty billboard. What business did it hype?

Life in the slow lane, that's where you find winsome ways and bucolic beauty. And wreckage. Lots of wreckage. It's thought provoking. I'll close with an observation. Something about the back roads brings me closer to nature. Patterns become apparent. Ever notice how many crows fly over the back roads? They're always darting about or hopping across a road. I think it's because they feel safer there. They seek food along the roads where they can dine on a scrap of food—flattened squirrel, perhaps. I've seen it many times. They understand there's less chance of being killed on a sleepy lane than on an interstate slammed with cargo-carrying eighteen-wheelers.

Maybe there's a lesson in that. Something to think about should you survey the wreckage along the back roads. Do it often enough, and like the crows and me you just might become a convert.

CEDARS AND CEMETERIES

I WAS ON THE PHONE driving through peach country near Johnston, South Carolina. A friend and I were talking books and hurricane worries when I drove by a cemetery. "Just passed an old, beautiful cemetery," I told her.

"Tom, why is it that cemeteries almost always have cedar trees around them?" she asked. It was a good question. This cemetery had cedar trees around it, and when I passed another cemetery and saw cedars around it, I got curious. I know it's common to see cedar trees along a fence line. Easy to explain. Birds eat the seeds and perch on the fences. Nature takes its course and the seeds sprout where the birds drop them. But cedars around cemeteries? That question sent me on a journey.

The cedar, I learned, is known as the "graveyard tree." Seems it's a practice to plant cedars around graves. Over in the Ozarks, superstition holds that when the cedar tree you plant around your grave grows tall enough to shade it, you'll die. Maybe that's because cedars take a long time to grow. You sure wouldn't want to plant a southern yellow pine near your grave. You'd be a goner in no time.

I learned a lot about cedars, death and graveyards. The Cherokees believed that cedars held the spirits of the departed. I learned that no other tree is mentioned in such high regard in the Bible as the cedar. So, cemeteries and cedars possess a religious connection. Also, the fact that the cedar is an evergreen renders it a symbol of everlasting life. Just don't try to relocate one. Legend holds that if you transplant a cedar and it dies, you will, too, and soon.

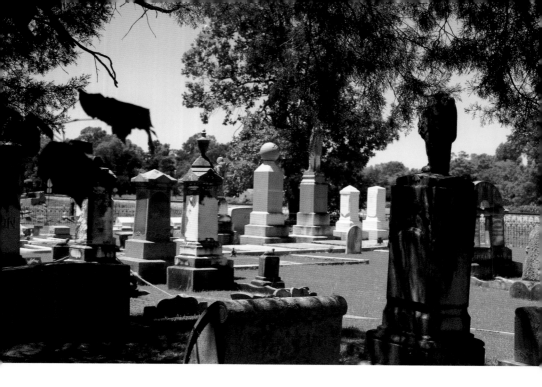

Another reason that you find cedars in graveyards, say some, is that their shallow root systems let them do better there than other trees. Makes sense given all the digging that goes on in a cemetery.

I've long railed against the corporate-run memorial gardens, with their manicured lawns, small metal "stones" and plastic flowers. In no way do these bland cemeteries offer the beauty and character of old graveyards, with their ancient tombstones and trees.

Give me a real cemetery with old stones and trees. One good thing about belonging to small churches in the South is that many of us have family plots. We know where we will be buried. I mean the very spot where we'll rest. I have stood on the exact spot where I will rest and thought mightily about life. I look around and see family members and friends who have gone to the Great Beyond. All have beautiful Georgia blue granite stones. Lord, thank you for not letting me be laid to rest in a place that looks like a campground where you hook up campers, RVs and Honda generators.

ABOVE Highway 23 near Ward. Cedars shade the Spann Methodist Church graveyard.

A few years back, Mom had our family plot worked on. She had granite coping laid down around it and crushed gravel spread across it. Now I'd much prefer grass to crushed gravel. And the plot needs a tree, in my view. In fact, the entire cemetery at New Hope Baptist Church back home is treeless save for one tree down the hill a ways. I may talk to the church elders to see if it's okay if I plant a tree near my grave.

> NOTE: You can spell crepe myrtle two ways: "crepe" or "crape." The common name is crapemyrtle. However, down South we spell it "crepe" myrtle because the delicate blooms resemble crepe paper.

And what tree might that be? Well, it won't be an eastern red cedar, the beloved do-it-yourself Christmas tree of the South. No, I'd like to plant a crepe myrtle there, one with brilliant red blossoms, watermelon variety. A splash of red and green in summer sounds good to me. And maybe some of its seeds will find a home for my sisters and parents. An oasis of crepe myrtles, with its elegant bare trunks and bursts of color, would be a good thing—far better than a plaque sunk into the ground with plastic flowers above it.

A DRIVE THROUGH THE BACKCOUNTRY

I LEFT THE "EMPIRE STATE OF THE SOUTH" the day after Mother's Day and headed to the Palmetto State. The border, mere minutes away, brought to mind the Allman Brothers' "Blue Sky": "Goin' to Carolina…won't be long 'til I'll be there."

I crossed where the Savannah still runs, albeit beneath a lake at this point. It was a good day to drive. Sunlight rained liquid gold, the sky intensified to deep blue and cottony clouds made newly minted leaves and grass greener than I remember. It was a beautiful day for exploring the countryside. My mission was simple: take heretofore untraveled back roads.

In McCormick, I took Highway 28 toward Plum Branch, where I turned left onto Highway 283, a backcountry road that hints of the South of the 1950s. Traveling it seemed dreamlike—like being in another country. I knew my parents had made summer trips down it seeking peaches for ice cream and pies. The road was beautiful and rustic, and I got great joy knowing that no interstate would blight my drive.

It didn't take long to spot delightful places. Not far out of Plum Branch I came across Deerfeathers Store. It's a colorful place. You used to see stores like this a lot. A concession to modern times, a Pepsi machine with its bright blue, red and white branding appeared out of place against an old cement wall. Grass edged the old store's front. The store hadn't opened in a while.

The regular gas pump—the only pump—registered gas at $1.86 per gallon. Two cedars, painted white and bereft of branches, serve as columns

for the tin overhang. Stubs where limbs once grew proved convenient for hanging stuff. Croaker sacks come to mind. Beneath the overhang were two homemade benches and an old cable spool, a table of sorts. You can be sure hunters chewed the fat here. No doubt they talked 'bout hunting whitetail deer, buck scrapes and guns. A sign over the door proclaimed a tournament of sorts: "Deerfeathers 13th Annual Big Buck & Doe Contest." How long ago had that been? Perhaps the gas pump held a clue.

I resumed my drive down Highway 283. Signs and several turns once again led me to Price's Mill, which you'll find east of Parksville on South Carolina Highway 33-138 (Price's Mill Road) at Stevens Creek in McCormick County. I found it but came across it so suddenly I shot by it. I crossed Stevens Creek and passed two men walking the shoulder of the road. At the top of a hill, I turned around in a driveway near gourds that hung from a pole, a great thing. When you see purple martin gourds, you know you are in deep country.

Doubling back to the old mill I pulled over to talk to the men. They were pulling up long green stalks. A feeling told me they were hunter-gatherers out for a meal, and sure enough they were. The younger guy came up carrying a large stalk with big green leaves. The older man standing spread-legged on the steep shoulder eyed me with suspicion.

"You guys must be getting up a mess of poke [polk] salad," I said. ("Poke sallet" is the proper name, but it's often pronounced as "poke salad.")

"Yes suh. My mama says it's great. Gonna eat some tonight."

Good for them. A free meal courtesy of a sun-dappled country road. Remember "Polk Salad Annie"? Tony Joe White's song recounts the story of a poor southern girl and her hungry family who lived off polk salad. White's song would have died a premature death had folks in Texas not loved it so. They kept buying it, and eventually it climbed the charts, furthering the legend of "polk salad."

White's lyrics don't tell us all we need to know. Pokeweed is a toxic plant. Country folk say it has to be "properly prepared," and that calls for boiling the plant three times, each time in a change of water. White's lyrics, however, perpetuate the legend of this plant of the South, which resembles spinach in taste and texture…they say.

The two men gathering a proverbial mess of greens appeared to be doing all right. For sure water would boil tonight. The friendly young fellow waved as I drove off; the other stared. How great it'd be, I thought, if the talkative fellow's mama were named Annie. As I eased off, I shouted, "Enjoy that salad!" and the friendly fellow waved again.

I coasted downhill over Stevens Creek and pulled onto a grassy area that faces Price's Mill. As I stepped from my car, a pack of dogs topped a knoll to the left of the mill. The leader was a pit bull. The dogs stood there snarling and yapping. The pit bull stepped forward. Now, not all pit bulls are ferocious. My late mom had one that was genial, timid even, but I wasn't giving this one a chance to teach me a lesson. Back into the car I went, which meant I did not get to walk down to the dam, where water tumbled away. Nor could I take up-close photos of old millstones on the porch.

Inside the circa 1890 rough-hewn pine building with a gabled roof, one R.A. Price worked seven days a week grinding out some fourteen thousand pounds of cornmeal per week. He died in 1968, and son John M. Price took over the operation crushing and pulverizing seven thousand pounds of yellow cornmeal in the early 1970s until a tractor accident killed him. The friendly polk salad picker up the hill had answered a question of mine. Now that answer took on an ominous ring.

"How long has the old mill been closed," I asked.

"Shoot, dat thing's been shut down ten years."

Shut down, but a beautiful reminder of our water-powered days. Price's Mill made the National Register of Historic Places on November 22, 1972. At the time, it was one of the few remaining water-powered gristmills in South Carolina. It made me sad to see the old mill. I have no doubt that someday—and it could be sooner than later—the millstones will fall through the porch. And then like dominoes all will tumble into a state called disintegration.

My drive through the hinterlands had taken me to places and things I wanted to see. Dirt roads, old shanties, vintage country places and more.

I took a county road and passed peach orchards that would soon be heavy with fruit. An abandoned home guarded them. It had a bay window gable, the likes of which I'd never seen. Still haven't. I motored through peach country and Johnston, a hamlet named Ward and towns called Ridge Spring, Monetta, Batesburg and Leesville. Along the way, I spotted a fine mural of a southern gent on a yellow brick wall.

Soon things changed. Turning onto Highway 1, modern life began to assert itself with a vengeance. Traffic picked up, and I passed wobbly boxes (aka trailers, aka mobile homes), flashing cell towers, high-voltage powerlines and a glossy, high-dollar medical facility. The trappings of modern life—billboards, quick stops and orange traffic cones—blighted the land. I had crossed the invisible line that decrees that old ways must surrender to new.

The road renounced the past where Polk Salad Annie found sustenance along roadsides and men used falling water to grind cornmeal. I had

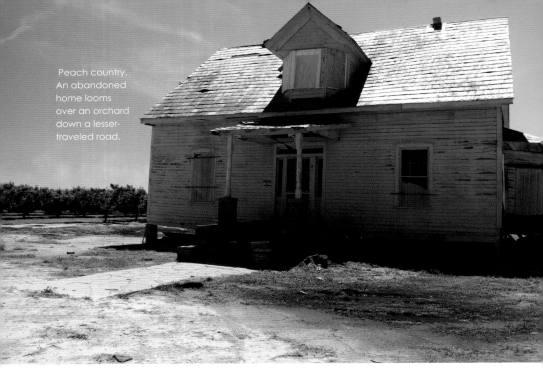

Peach country. An abandoned home looms over an orchard down a lesser-traveled road.

abandoned the land of orchards and old homes for high-tech traffic lights and digital signs. The land of tree stands and large tracts of forest no longer existed. Old tractors wreathed in vines were nowhere to be found. Yes, I had crossed the border into a place called Urbanization. But it's not just swallowing you and me. It's omnipresent.

I vowed to go back to Highway 283 and take photographer Robert Clark with me. I vowed to drive its cousins too. There's beauty and majesty along highways assigned to the 200s, and I aim to travel more of them, places where traces of simpler times cling to a precarious existence. There, memories live on along forgotten highways where yesteryear's South makes its last stand.

AN OPEN-AIR CINEMA
SHINES ON

On U.S. 1 near Monetta, you can relive an experience like few others. There was a time when the whole family would pile into the car and head to the drive-in. Come dark, Hollywood idols flickered across the silver screen, shooting stars pierced the night and the aroma of grilled hot dogs and buttered popcorn filled the air. There was nothing like a little movie magic while sitting in your '56 Plymouth or '57 Chevy.

Well, you can still enjoy that open-air cinema, the drive-in. Yesteryear's cinema served Milk Duds and hosted classic movies like *East of Eden*, *Some Like It Hot*, *Vertigo*, *Ben-Hur*, *Dr. Zhivago*, Disney's *Sleeping Beauty* and goofy horror classics like *The Blob*.

Back in the day, teenagers who borrowed dad's car found the drive-in an ideal place for dates. At the evening's end, corny cartoons warned patrons to replace the speaker on its rack before driving off. Still, many a teen drove off taking a speaker with him or her—or worse, shattering dad's driver-side window. The drive-in also tempted teenagers to catch a free show.

We can thank Richard M. Hollingshead Jr. of Camden, New Jersey, for the drive-in. In 1932, Hollingshead conducted outdoor theater tests in his driveway. After nailing a screen to trees in his backyard, he set a 1928 Kodak projector on the hood of his car and put a radio behind the screen, testing sound levels. Blocks under vehicles in the driveway helped him determine the size and spacing of ramps so all could see the screen. Soon, the drive-in was off and running into the annals of Americana.

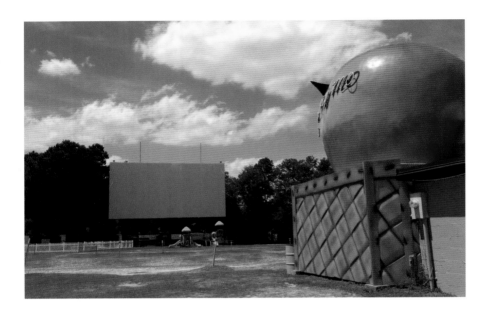

The drive-in's popularity peaked in the late 1950s and early 1960s, particularly in rural areas, with some four thousand drive-ins spreading across the United States. Among its advantages was the fact that a family with a baby could watch a movie without having to hire a sitter.

A cultural icon of the '50s, the drive-in is an endangered species today. The ever-climbing price of real estate, affordable color TVs, Daylight Savings Time and the advent of VCRs and video rentals did the drive-in in. About four hundred remain in the United States.

When Richard and Lisa Boaz opened the "Big Mo," as it's known, in March 1999, they saved a cultural icon. Sam Bogo opened the drive-in on April 26, 1951, and it prospered until the early 1970s, when multiplex theaters debuted. Bogo closed it in 1986.

When the Boazes bought it, the marquee letters had long spelled "Closed for Vacation," and although they had blown away long ago, sunlight had burned the text into the concrete. Well, the vacation's over. The Boazes opened the Big Mo with *The Wizard of Oz*, and cars keep rolling in for family films and a return to the '50s. It's an experience we old decrepit baby boomers ought to relive one more time.

ABOVE Come sundown, the screen comes alive. Off US 1 near Monetta.

Dusk. The lights drop. Startled kids hustle from the playground to their parents' cars. "The Star-Spangled Banner" plays to a chorus of patriotic car horns, and an archaic 3,600-watt projector beams magic onto the screen. Cars from Augusta, Aiken, Columbia, Myrtle Beach and points in between dial into FM 90.3 for audio superior to the old window speakers. A few kids stroll to the concession stand in pajamas. All come to enjoy that one-time mecca for wanderlust teenagers: the drive-in.

Many romantics will confess that their first kiss and first drive-in went together. The drive-in still exudes romance. "Couples will have their first date here, and they'll come back a year later to get engaged," said Richard. "We're waiting to cater a wedding with corn dogs and popcorn," added Lisa.

Frequent patrons get Stargazer cards for prizes, and it's no exaggeration. The Monetta night sky, free of big-city light pollution, sparkles with celestial treats. One night, a total lunar eclipse occurred, and "one year," said Richard, "Mars put on a fantastic show."

Rediscover what it's like to be seventeen again at a '50s icon in Palmetto peach country, the Big Mo.

DOWN A GRAVELED ROAD

PART I

LATE MAY, A BEAUTIFUL DAY. A blue sky, cotton ball cloud kind of day. Photographer Robert Clark and I are deep in the woods of western South Carolina photographing historic sites for a book. Beyond McCormick, we round a curve, and the sky turns a menacing yellow. The smell of burning woods fills the car, and Robert spots a cloud much different from the rest. "There's the fire," he said, pointing slightly northeast.

A yellow plume of concentrated wood smoke ascended. It occurred to me that photography under these conditions wouldn't be possible. Just the opposite. Robert said the smoke would render the sunset spectacular, rife with color. Fire…we'd encounter it again before the day was done.

Highway 378 is a highway of change. Used to be pastoral. Not so much anymore. Clear cuts and old stores torched by arsonists are just a few of the eyesores. Metal buildings and mobile homes conspire with piles of junk to ruin things.

In McCormick, we checked in with the chamber of commerce. We needed a way to get into the old Dorn Grist Mill. Anne Barron, director, and Dot Bandy greeted us, and soon Dot led Robert and me through the mill. Right off we walked past a 1914 boiler built by the Lombard Iron Works of Augusta. That "modern" boiler powered this 1898 attrition mill, where grinding plates revolved in opposite directions at 2,200 rpm. When this mill was up and running, the din must have been unbelievable. Now all is quiet. The hand of time stills the great gears, wheels and cogs. Anne Barron said the mill still works. It just needs someone to run it.

Multi-hued beams, chutes and railings gleamed blond, red and tan, and the thick brick walls supporting all things wooden kept the heat out. Much cooler than I expected. Beautiful, too, is the Silver Creek Flour Packer that funneled flour into bags, thereby earning its name. Manufactured by the S. Howes Company Eureka Works, it came from Silver Creek, New York. Silver Creek Flour Packer indeed.

What impressed me most was the building itself. It has a medieval look. Listed in the National Register of Historic Places, it's praised as "an outstanding example of rural industrial architecture." Out front stands a low squatty brick monument with a plaque:

THIS TABLET IS ERECTED IN GRATEFUL
APPRECIATION OF THE MUNIFICENCE OF
MRS. NETTIE F. MCCORMICK,
WHO DONATED THE SITE OF THIS BUILDING.

Munificence—a word you don't come across often. Patrician.

That afternoon, we drove up Highway 28 to Abbeville. We had a two o'clock appointment to tour the Burt-Stark Mansion. Ruth Bacon met us at the front steps, and we walked into history. You don't have to go to Gettysburg to witness serious Civil War history. It's close by. Abbeville is often referred to as the birthplace and deathbed of the Confederacy, and with good reason. Abbeville's Burt-Stark Mansion, known also as the Armistead Burt House, is where the Confederate Council of War cabinet members last met.

The birth took place at Secession Hill when local citizens gathered on November 22, 1860, to adopt the Ordinance of Secession. A few hundred yards and four and a half years later, the Burt-Stark Mansion is where the will to fight left the Confederacy's leaders.

Historian Fred Lewis gives an account of this key moment at the Burt-Stark Mansion. "As the Civil War approached its end, President Davis left Richmond, Virginia, on April 2, 1865, heading southwest. He reached Chester, where he was invited to Burt's home for a time of rest. He arrived in Abbeville May 2 accompanied by nine hundred to two thousand Confederates. He arrived at the old home around ten in the morning. After 'supper' that evening, he met with Secretary of War John C. Breckenridge, military advisor Braxton Bragg and five field commanders in the men's parlor. His attempt to obtain support for another effort against the Union failed. Convinced not to pursue a guerrilla war against the Union, Davis says, 'Then all is lost.'" A shaken Davis had to be helped upstairs, where he rested in a four-poster bed.

Making our way toward Mount Carmel, we found Highway 823, a back road if ever there's one. On this lonesome road, we were looking for the Calhoun Mill, and we found it not far from a rusting steel bridge over Little River. Think of a scene from *Fried Green Tomatoes*. Just off a side road at the end of the bridge, we parked and trudged through a thick field of vetch saturated in lavender blooms. At the far edge of the vetch stood the mill, luminous with low-angled sunlight. Backtracking, we drove across the bridge and found the dam where the mill got its power. Some locals were having a good time. They eyed us with suspicion, but a friendly young woman ("I write poems") led us to the riverside. A Chattooga-like setting met us. As we photographed Little River and the old milldam, a man trudged by with two good-sized channel cats. Fried fish tonight!

Back in Mount Carmel, a ghost town, we spotted a quaint church, picturesque but abandoned. With a simple architecture and elegant lines crisscrossed by vines, the Old Mount Carmel Presbyterian Church sits there, its paint peeling away. Across the street sits an old home ceded to tangled greenery, old landscaping turned feral. Easy to conjure up the ghosts of that home drifting through broken windows at dusk, settling light as feathers on the old worn, forlorn steps.

Too many nice homes have surrendered to shrubs and vines. Oh, and like bookends, another abandoned church stands at the opposite end of Mount Carmel, the Mount Carmel Associate Reform Presbyterian Church. The Savannah River Railroad helped Mount Carmel prosper in the 1880s, but something went wrong. What happened? Well, a series of events.

In the summer of 1896, fire destroyed part of the town. During a burglary, a kerosene lamp fell over, and four homes and twelve businesses turned to ash. Several businesses were rebuilt, brick this time, and the brick came from D.B. Cade's brickyard. So the town carried on…for a while.

How does change choke the life out of a town? Like this. The arrival of the automobile lessened the railroad's value, and folks began to move in a quest for jobs. In 1921, the boll weevil infestation devastated Mount Carmel's cotton-producing areas. The Great Depression delivered the knockout punch.

With the sun dropping fast and my gas gauge hovering at "E," I drove us out of there. Outside Calhoun Falls, we gassed up and made our way across Lake Russell into Elbert County and down Highway 79, past my mother's childhood home into Lincolnton, Georgia.

>>>>>

An early Georgia morning. Fog drifts through the pecan orchard across from my boyhood home. Spider webs bejeweled with dew put up silver tents in green pastures.

We drive back into McCormick, where Janice Grizzard, director of the McCormick Arts Council at the Keturah, gives us a tour of Hotel Keturah. This circa 1910 building is in the National Register of Historic Places. In front of the hotel, Janice points out six stones sunk into a sloping shoulder of grass just off the rail tracks. Black gentlemen in tuxedoes escorted train passengers to Hotel Keturah down those rocks. Keturah, by the way, is the name of the wife of W.J. Conner. And who might he be? Well, he's the man who built not one but two hotels on this site and named both in his wife's honor. (The first Hotel Keturah, 1900, burned in 1909.) Janice told us how to find Badwell Cemetery, and we struck out again on our exploration of a historic land.

Hitting 378 again, we turned onto Huguenot Parkway. We stayed on it all the way through Savannah Lakes, a lake community, and soon we spotted a road to the right, Badwell Cemetery. We drove down this sandy lane, and turning left and driving some more, we hit a turnaround where the gleaming white spire of a monument broke through greenery. We parked near a beech tree, where souls have carved sentiment and messages into its aged bark. Looked a bit like hieroglyphics.

We found the cemetery downslope near water. Legend says that a troll guards Badwell Cemetery. We saw no evidence of a troll—an odd haint—but a courageous terrapin met us near the entrance. I nudged the fellow with my foot, but he remained unperturbed. The entire time we were there he never left. Surely he wasn't a shape-shifting troll?

A rock wall, partially caved in, protects the cemetery. Well, it tried to. Years back, thieves made off with the Grim Reaper sculpture that adorned the wall's iron door. Thank goodness it was recovered and now sits in the South Carolina State Museum. What a photograph that would have made.

I'll never forget this graveyard, and not because notable French Huguenots such as Reverend Gene Louis Gibert and members of the Petigru and Alston families lie here. No, credit for this bittersweet memory goes to the inscriptions on a four-sided white marble marker:

SACRED TO THE MEMORY OF MARTHA PETIGRU,
ONLY DAUGHTER AND LAST REMAINING CHILD OF THOMAS
AND MARY LYNN PETIGRU,
AGED 25 YEARS, 1 MONTH, AND 16 DAYS.

HER SUN WENT DOWN
WHILE IT WAS YET DAY.

BORN SEPTR. 16TH 1830
DIED NOVR. 2ND 1855

HER SUN WENT DOWN WHILE IT WAS YET DAY, JEREMIAH 15:9.

With a ringing mandolin and "Copperhead Road" playing in my head, we set out looking for a memorial to the site of a Huguenot place of worship. On we drove, down graveled roads far from the city. And then we turned onto a dirt road with a strip of grass in the center, deeper into pines. And then we saw it: a Maltese cross that marks the New Bordeaux Huguenot place of worship.

New Bordeaux, in 1764, was the last of seven French Huguenot colonies founded in South Carolina. The French settlers brought the European model of agriculture here. Fruit trees, olive gardens and vineyards sprang up. The village prospered in the 1760s and early 1770s, but the Revolutionary War ruined things and New Bordeaux faded into oblivion. Looking around, I saw nothing but pine trees—no river, just the lake. Marble monuments and rock walls, though they endure.

DOWN A GRAVELED ROAD

Part II

THESE WESTERN SOUTH CAROLINA BACK ROADS take me back a long ways. After my high school football days were over, I entered the University of Georgia. For two summers, I worked at Elijah Clark State Park, right on the border. I was one of the garbage men. We went from campsite to campsite on a Massey Ferguson tractor—red, of course—that pulled a wooden trailer. We'd empty trashcans into the wagon and dump it all in a huge trench in the backwoods. Now and then for lunch, my co-workers and I would leave dry Lincoln County for the cold beers we could legally buy at Gates in Bordeaux—along a back road. Yes, these roads take me back.

It's a hot July day. After a long morning of hauling garbage, it's lunchtime. Off to Carolina we go. I'm driving a 1961 white Plymouth Valiant with a three-speed on the column. Blue interior. We're headed down State Road S-33-7, a back road to Bordeaux, to buy cold red cans of Carling Black Label and chilidogs at Gates. With onions.

The gravel in the road catches the noonday sun and sparkles. We leave Gates and head back toward Georgia but stop to eat our lunch on the South Carolina side at a picnic spot no longer there. We'd sit there and eat and sip, oblivious to the history around us. I had never given the name Bordeaux a second thought. I knew nothing of New Bordeaux—that it was the last of seven French Huguenot colonies founded in South Carolina. I did not know that the colony was settled in 1764—252 years ago—by a group of French Huguenots led by Jean Louis Gibert and his followers. I did not know they

had fled their village in France in search of religious freedom and eventually established a church along the banks of Long Cane Creek.

Much later, after I moved to South Carolina, I would learn that the French brought a European form of agriculture here. They planted fruit trees, olive groves and vineyards and began producing white and red wines. And why shouldn't they? Bordeaux, France, is the hub of France's famed wine-growing region.

They say that growing old is not for sissies, but age opens your eyes. Once again, I'm driving that road of youth where an underage Georgia boy could plunge his hand into an old cooler filled with chunks of ice and fish out a cold beer. I remember the piney woods isolation and excitement of doing something illegal "'cross the line." Otherwise, driving down a graveled road through desolate areas back then seemed a desperate way to get, well, somewhere.

The road looks the same, but the eyes of the boy and eyes of the man see things differently. Historical markers now hold more interest than beer signs. And here's a marker straight ahead: the John de la Howe School.

When I was growing up, orphans existed only in novels and movies. I never knew an orphan, yet many were close by. John de la Howe, a physician from France, founded his school in 1797 to provide destitute and orphaned children an education. The school is a complex of buildings, among the more beautiful of which is a barn. Built in 1931 for dairy cows, today it's a country marketplace and concert hall, but we're not here to be entertained. We come to photograph a tomb. In the 1980s, Robert had photographed De la Howe's tomb for *South Carolina Wildlife* magazine, and he wanted to see it again. Today, he's with me, and I want him to photograph Price's Mill.

We turned off Gettys Road to Tomb Road, a lengthy road dead-ending at De la Howe's grave. Orange strings crisscrossed the small cemetery. It looked as if an archaeological dig was about to commence. Not sure De la Howe would be pleased. His will left specific instructions about his burial arrangements. His grave was to be unmarked and surrounded by a wall ten feet square, eight feet high and two bricks thick. It was to have a steel door and lock but no roof and the site kept in good order. Perhaps the grid of strings hints of preparation for plot improvements. Perhaps the old doctor will be happy once again.

I photographed the old tomb, but Robert declined; the strings ruined things. We made our way back to Gettys Road, cruised through the De la Howe complex and then hit Highway 81. We traveled through the Sumter National Forest, Long Cane Ranger District.

"Around these parts," as they say, you pretty much have the road to yourself. Well, almost. Log trucks thunder down these roads. Big trucks laden with big logs—massive hardwoods and utility pole–like pines. Logging and pulpwood constitute a big industry here. Old clear-cuts regenerate amid profusions of sweetgums, pines, tousled vines and rotting wood. Trees are a renewable resource...still.

When a log truck rumbles by, I think of how these woods must have looked before the saws came. Sometimes I think of how this country must have looked before settlers arrived. When log trucks rumble by, the leaves of wise old oaks along the roadside tremble.

As we made our way onto State Road S-33-135, smoke stained the horizon a dirty yellow. Smoke would bedevil us the whole trip. The Sumter National Forest's Long Cane Ranger District sprawls along the Georgia border, and it was time to burn away its understory.

For years, foresters suppressed all fires. The philosophy that any fire is bad proved fallacious. Now foresters intentionally start fires to make the woods safer, healthier places. Fire, a natural occurrence in southern pine forests, keeps ecosystems balanced by eliminating understory vegetation. Burning off brush, limbs and pine needles reduces the risk of wildfires. And boy does it make for a lot of smoke.

Soon we passed men with two-way radios on ATVs. With radios tight against their heads, they darted in, out and around surging rims of fire. Tongues of fire licked the pines and smoke boiled into the sky. Showers of sparks started fires of their own. Smoke slipped into the car's ventilation.

It would not be our last encounter with fire.

>>>>>

When the sun reaches its zenith and shadows shorten, light turns flat and photography's no good. And that's when scouting takes precedence. With breathing room as photo time fades, we decide to retrace the drive I made through Edgefield County a few weeks earlier. Robert wanted to see Price's Mill, an old gristmill with its glory days in the rearview mirror.

We drove into McCormick and turned right at the Hardee's. In Plum Branch, we turned left onto Highway 283. To get to Price's Mill, we followed signs and drove down several graveled roads.

When we arrived, not only was the light flat, but someone had also parked a Toyota pickup slap dab in front of the mill. As Robert took shots from angles, I walked the property trying to get a feel for how things might have

been during the good days. Right in front of me was a tractor taken over by vines and saplings. A shrub covered the driver's seat. Directly behind the tractor and across the graveled road stood a timeworn farmhouse. It seemed abandoned. I composed a photo with the tractor and the old farmhouse behind and to the right. "Death of a Farm."

Death of a mill operator. A woman in McCormick told me that a tractor overturned and killed John Price, bringing an end to the old mill's run. That tractor in vines—surely it wasn't the one? Did they just leave it right there? I would learn later that, yes, it was the one.

We left the old mill where a table had been made from an old millstone. Again we were deep in Sumter National Forest, and soon the old dictum that two pairs of eyes are better than one proved true. Nineteen days earlier, I had crossed the Highway 283 Bridge over Stevens Creek solo. Uneventful passage. This day I crossed it again, and at the far end, Robert shouted, "Turn around. I see flowers."

We re-crossed the bridge, stopping on it for a better view. Downstream in a sweeping curve, the creek breaks right and rocks create riffles. There, just barely, we could see clumps of white flowers…surely it couldn't be.

Surely it was. Rocky shoals spider lilies, a rare and beautiful flower. We crossed the bridge back toward Plum Branch and parked. We got out and walked down a lane carpeted in pine needles. A "No Trespassing" sign hung from a stout cable. No other way in unless we wanted to wade through hip-deep water or tightrope across a rusty pipe that looked as if it would collapse.

A call or two later, we were told that if we wanted to photograph the lilies up close, we'd have to descend the steep, high bluff on the far side of the creek—more like a river, really. We headed back across the bridge and pulled into a side road barricaded by a gate. We got out, unloaded the cameras, tripods and accessories and trekked uphill for several hundred yards. Then, through an opening far below, there they were: showy flowers bobbing about, resplendent in afternoon sun.

The steep bluff dared us to descend. Its tangled vines and brush promised to trip us. Trees burst out of the ground at an angle. Or so it seemed, thanks to the abrupt way the land fell off. Right away we both fell. Robert's camera bag tumbled downhill until a helpful tree blocked its plummet. I caught myself on a sapling and swung around, my camera banging against me.

We made it to the bottom, where recent floods had muddied things and rocks were coated in slime. Dangerous footing. Photography commenced. The flowers preened like stars. Gleaming white with dark green foliage, they gently swayed with the creek and wind, bowing with grace like leading ladies.

Taking photographs of such beauty satisfies a creative craving, but clouds of ravenous mosquitoes put a dent in the joy. Mosquitoes aside, all was good, although now and then I heard strange noises on the bluff above. Something crashed through the underbrush up there…deer? Dogs? Wild hogs?

We moved farther downstream to get closer to a profusion of spider lilies. That name comes from six long, slender petals beneath the main bloom. Altogether it gives them a leggy spidery look. Rocky shoals, well that's the habitat where they flourish. Rocky shoals spider lilies. Man has dammed so many rivers that the lilies are between a rock and a hard place.

Things were going pretty good, but climbing the bluff to our back preoccupied me. We had gear to carry up. Worries over a fall and broken leg or snakebite are never out of my thoughts when we're afield.

From atop the bluff, a deep and resonate *thud* shook the air. Another. And another. More *thuds* shook the air as we moved to get a new angle on the lilies. I was taking a few shots of Robert in action when fog rolled across the water downstream. A Deep Purple moment, although conditions weren't right for fog. And then the woods on the bluff behind us crackled and popped. Looking straight up behind me, orange and yellow flames leaped through pine tops. The *thuds* had been gasoline exploding. Wood smoke rolled down the bluff all around us.

"Robert, the woods above us are on fire."

He looked up at the bluff. "We won't burn with this creek right here. Besides, the smoke gives my photographs character." He resumed taking shots.

I looked up at the bluff. Sure, we could wade into the creek, but the smoke downstream hugged the water. Why wouldn't it do that where we stood? Smoke inhalation worried me.

We kept taking photos, and I scoped out a series of rocks I could step across to escape any fire that might come down the bluff. Then, downstream, a *Deliverance* moment. A man—a U.S. Forest Service ranger—walked out to the edge of the creek right into Robert's frame. "Let's go," Robert said. And it was time for us trespassers to vamoose.

We never saw fire as we made our way up the bluff, going out of our way up a gulch and taking a longer path back that wasn't as steep. Other than a bit of smoke and encountering what appeared to be a downed power line, dead, we had no problem.

Back at the car, Robert made a pronouncement. "The spider lilies, they made the day."

»»»

We headed to Edgefield, where artsy fiberglass turkeys adorn corners, streets and porches. The National Wild Turkey Federation headquarters is near here, and the bird of wattles and bronze feathers is a big deal. Then we hit Highway 23 and called it a day. Or so we thought. Driving through the hamlet of Ward, we spotted an exceptional cemetery beside Spann Methodist Church.

The church had its start around 1805 as part of the plantation of John Spann Jr. The cemetery that caught our eye came to be in 1840. More than a few Confederate soldiers sleep here, as does the founder of Ward, Clinton Ward, alongside his wife, Martha, and their only child, Josephine. Little Josephine stands atop her monument, a haunting statue. She died at six. Her sun went down while it was yet dawn. The statue of Clinton, with his period-vogue mutton chops and beard, stands atop a tall monument. A large sphere tops Martha's.

Unusual, too, is the cast-iron statue of a deer at the cemetery gate. A statue of a dog by a tree stands near the railroad track. Ward's marker, his wife's, the deer and the dog made the Smithsonian's Inventory of American Sculpture. The church and its cemetery made the National Register of Historic Places. Not your ordinary graveyard.

Something about cemeteries soothes me. I like to walk among the stones reading inscriptions. As the sun sank and Robert took photos, I stood behind Clinton Ward's statue, which makes it appear that he's staring at a distant water tank. And why wouldn't he. On that tank is one word: "Ward." To the left of Ward's grave is wife Martha's. How interesting it'd be, I thought, to get a shot of Ward looking at the water tank. I took the shot. Light struck the lens, creating what photographers refer to as flare. I got a bit of a jolt when I downloaded the images. Orbs floated around Ward's statue. Believers of things paranormal refer to them as ghost orbs. Maybe so. Maybe I should claim to have photographed spirits. Maybe I won't.

The biggest surprise was not the orbs. It was the ghostly aura coming off the marker behind Martha's grave. Maybe, I fantasize, a spirit that haunts Badwell Cemetery from our earlier trip hitched a ride with us in the hopes of finding a new cemetery, a place where kindred spirits convene come sundown. And here, with the unusual stones and statues, it found a place to its liking.

We certainly did on our two-day swing through the Old Ninety-Six District. We came, we saw and we documented captivating sights and places sequestered down graveled roads.

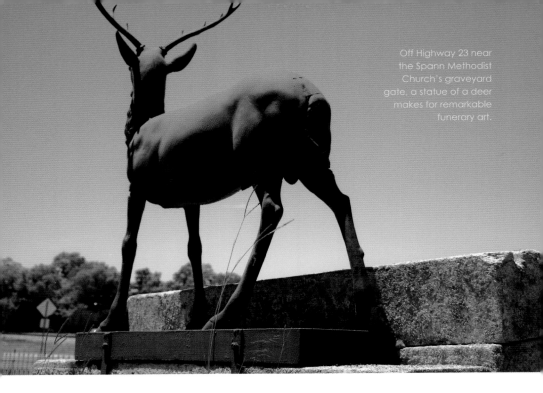

Graveled roads. That's where I find evidence of bygone times, when life seemed more real and more beautiful. My romantic side longs for the good old days, but some folks say that the good old days weren't so good. I don't want to agree, but I know they're right. People worked so hard back then. Simple things killed you. Lots of backbreaking work running old mills and chiseling out rock walls. And then for all your good work your child dies at an early age—the sun went down early when it was yet day. I don't think I'll get any argument from the parents of Martha Petigru and Josephine Ward that the good old days were not just bad but sad. So, if I could, just once, how lovely it would be, how sweet it would be, to place one rocky shoals spider lily on the little girl's grave. Just one.

A COUNTRY STORE
CARRIES ON

IT'S BEEN CALLED THE BEST COUNTRY STORE in South Carolina. You can buy Virginia cured hams there, and you can buy gas, diesel, propane, shotgun shells, wrenches and frying pans. Why you can even buy red hash, fig jam, hoop cheese, Blenheim's Ginger Ale, cheap wine and hog heads for headcheese. As country stores in this part of the South go, it's famous. Its fame, in fact, earned it a spot in *Garden & Gun*. So, if you have a hankering to see a survivor, an honest-to-goodness country store, get in your car and drive to the intersection of 377 and US 521 to Salters, South Carolina. There sits Cooper's Country Store.

The red-and-white two-story store commands the eye. The Exxon sign on top of the living quarters adds its splash of patriotic colors to the setting. So does the Pepsi sign. The store is classic, and just about everything about it delights the senses. Go to the rear and stand near the fine Southhampton hams hanging in a screened-off cage. Inhale an aroma that has been making mouths water for decades.

Everywhere you look, a jumble of sights pleases the eyes: cookies, candies, hand-lettered signs and, for a while, an amazing table featuring the shiny brass heads of 12-gauge shotgun shells. Fan belts hang on racks. The bacon here makes many a breakfast a feast.

Toilet tank repair kits, eyebolts (good for hanging Pawley's Island hammocks) and collectible but not-for-sale old farm implements grace the store. A precursor in a way to Walmart, old country stores like Cooper's provided just about anything country folk needed.

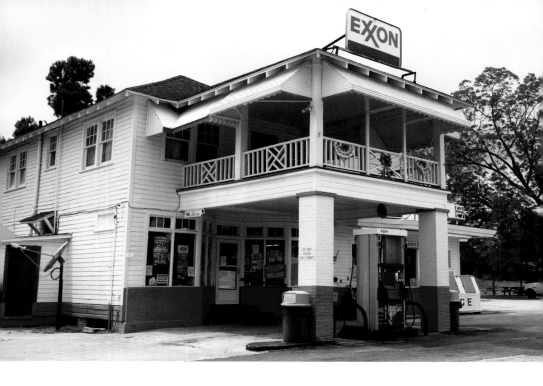

Cotton farmer Theron Burrows built the store in 1937. Known from the start as Burrow's Service Station, it sold Esso gas. The name changed in 1974, when Burrows's son-in-law, George Cooper, and Burrows's daughter, Adalyn, took over the venerable store. Russell Cooper runs the store today.

Like a lot of old country stores that surrendered to time, Cooper's Country Store is a two-story affair with a home upstairs, where the proprietors once lived and occasionally still stay. The French have a beautiful architectural term describing the covered entrance beneath which vehicles drive through: "porte cochère," a porch where vehicles stop to discharge passengers. Well, you can be sure a lot of vehicles and passengers have passed through here, and so should you.

I should issue a warning to people hell-bent to get to the beach: Don't stop at Cooper's Country Store. You'll linger longer than you intend. God knows you may end up late to the land of traffic congestion and wacky golf. But for those who want to see what was a common part of their grandparents' lives, you'll find the old store at the intersection of 521 and 377, where the past meets the present.

ABOVE Cooper's Country Store. Step through that white modern door and you step into the past.

THE UPCOUNTRY,
THE BEAUTIFUL

IN THE UPCOUNTRY, back roads provide startling views. I've seen this firsthand. Case in point: from a cattle farm's lush grassland in a dale beneath the Blue Ridge Escarpment, the sunrise slides down the distant rock face as I stand in lingering night shadows. That curtain of light sets the day to stirring for man and beast alike.

I heard about it several years ago from a man who grows fruit: Dick Perdue, who long has risen early to stunning views. Perdeaux Fruit Farm (formerly Perdue's Mountain Fruit Farm) in northern Greenville County delights residents and tourists with colorful, fragrant fruit. Want to savor the sweet, popping burst of a crisp, juicy mountain apple as you take in spacious skies and purple mountain majesties above a fruited plain and perchance see a black bear stand to better see you? How about the subtle, sweet scent of an open jar of honey shot through by sunlight, golden and aglow? Or how about the dewy sweetness inside an Elberta peach's velvety patina of sunrise colors? Head to the beautiful Upcountry.

Perdue chose the location for his orchards along the Cherokee Foothills Scenic Highway because of its promising blend of climate and geography. A bonus came as well: early morning splendor. "I get up at 5:30 a.m. each morning," said Perdue. "In early morning light, the mountains are blue and covered in white haze. When it rains, fog banks form." Another bonus is hard to beat: solitude. "When I am up my farm's ridges, I see no signs of man—none whatsoever."

Perdue has long driven up scenic SC 253 every day. "There is a high point about a mile from Tigerville where I get a beautiful view of the Blue Ridge Mountains' southern end. I look straight at the stone face of Glassy, where hang gliders jump off. To the right sits Hogback Mountain. One day, the sky will be clear with no clouds. On other days, the haze can be so heavy you can only see the outline of the mountains in the skyline."

As Perdue drives up in altitude, the land goes from mainly pine trees to hard woods. "Especially after you cross Highway 11, oaks, tulip poplars, sourwood, red maples, cherry, sweet gum and hickory take over. With these hardwoods, along with lots of dogwoods, we usually get a beautiful leaf color display each fall."

Perdue, who's a tad retired now, loves driving through his farm. "Quite often I run into a flock of big old tom turkeys eating fruit. They're so used to me I have to blow my horn to get them out of the farm road. Come spring it's fun to see and hear these fellows all plumed up, debating and fighting over nearby hens. Then I'll see a gray squirrel running for the woods with a big chunk of apple or peach in his mouth."

Soaring overhead are turkey buzzards and red-tailed hawks, while below, bird music fills the air. "I often hear an owl hooting in the nearby woods or a woodpecker rattling a dead tree. The biggest excitement we have with wildlife is black bears. They are very selective in the fruit they eat," said Perdue. "They only eat the sweetest apples. They don't like Granny Smiths! We often run into one bear in the middle of the day. He runs one way. We run the other."

How can a bear resist the scent of fresh fruit? Can you? Hit the back roads of the Upcountry come fall. Apples and more wait for you. Waterfalls, for instance, along secluded roads.

LAND OF FALLING WATERS

Here in the Upcountry, you'll find waterfalls beautiful to behold, each different. Ease up Highway 130 near the North Carolina line to glimpse Whitewater Falls' twin falls, plunging more than four hundred feet downward, the state boundary running between them. Whitewater Falls, on the Foothills Trail, a short distance from the summit, is the highest vertical falls in the eastern United States.

Oconee Station Falls, known also as Station Cove Falls, won't disappoint you. It flows over the edge of a sixty-foot-high ledge at the end of a 0.7-

mile trail in Oconee Station State Park near Walhalla. This park, by the way, features several Revolutionary War–era structures worth seeing. You won't find it along an interstate. To see this waterfall, drive from Walhalla, taking SC 183 north for three miles to SC 11, the Cherokee Foothills Scenic Highway. Follow SC 11 north for two miles. Look for signs directing you to Oconee Station State Park.

One morning, I hiked to Cove Station Falls. Along the way, I saw large paw prints in creek sand that looked like an eastern cougar's, though it couldn't have been a catamount, could it? More likely the prints, enlarged by moving water, belonged to a bobcat. At the end of the half-mile hike, there stood the falls: sixty feet of falling water split into two bridal veil–like cascades. Just seeing the falls made me feel more alive.

In the Upcountry, you'll find beautiful waterfalls, each different, off beaten paths.

A FONDNESS FOR OLD GAS PUMPS

IN THE COUNTRY, you'll come across transportation veterans: old gas pumps. Something about them pleases me. I think of them as elder statesmen. When I see a proud old pump, its dispensing days behind it, I feel a tinge of sadness. It's been put out to pasture.

I have a long history with gas pumps, and you do too. Ever wondered how many hours you've stood by a gas pump over the years? The answer is plenty. Ever worked at a place where one duty was to pump gas? I have.

My first job was at Goolsby's store on Georgia Highway 47 bagging groceries, stocking shelves and pumping gas. I liked how the old pumps clicked off increments as gasoline flowed into cars and trucks. I liked, too, the glass bubbles where gas swirled around. "Glass must be full before delivery." And who can forget the old pumps with glass globes. Old pumps amount to works of art. I've had a fondness for old gas pumps ever since.

Only once did pumping gas concern me. Down at Goolsby's Store, I pumped regular into a car whose owner wanted "high test." The way he reacted to receiving regular made me think I had mixed nitro and glycerin and his car would explode when he started it up. Of course, all was fine.

Back in my early years of driving, an old pump often got the last dollar I had. I got my money's worth though. A dollar's worth of gas would keep me rolling a long while. Not so today. Today's gas prices vary wildly from day to day, and any excuse is justification for shooting up the price nineteen cents a gallon overnight. Back before all this global concern shifted logic upside down, the old pumps were stalwarts of stability. Not so anymore.

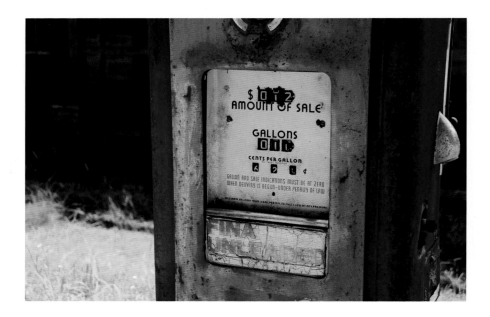

No matter the price of gas, you must admit that gas pumps serve an indispensable role in life. We can't get very far in our mobile society without them. Having said that, let me add that I don't care for the modern digital pumps that put on the brakes as you near the end of your purchase. The last gallon takes as long as the previous five. And most of all, I absolutely detest the pumps where an ad plays as you fill your vehicle. Mute them.

The old pumps had class. They weren't half pump and half robotic salesman. My Granddad Poland had a stately old pump down on his farm. It provided the fuel that his tractors, trucks and cars needed. It's been gone for decades, but I can lead you right to the spot where it stood. That pump and a few others fuel my interest in abandoned stores and old farms. To this day, when I spot a lone pump at a shuttered country store or what was once a farm, I try to get close and read the price of gas per gallon off those old dials.

ABOVE Near Nesmith in front of Cook and McLean General Store. Fill 'er up.

OPPOSITE Wreathed in honeysuckle, this old pump in Mount Carmel gives new meaning to "going green."

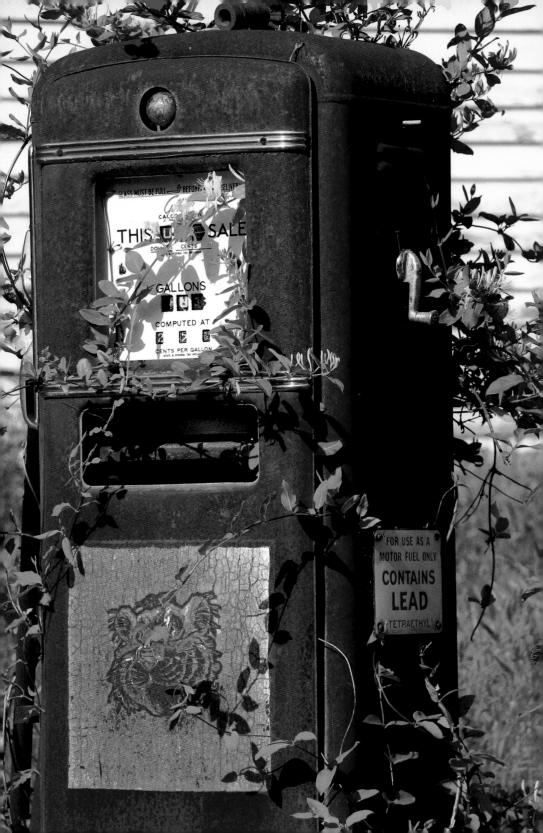

In Mount Carmel, you'll find an old pump that has gas at exactly twenty-five cents per gallon. I like this old pump a lot. I even like the warning that it contains lead; that was to keep cars from knocking. I like the old Esso tiger on the front. "Put a tiger in your tank." Remember that? Of course, Esso became Exxon. Once known as Standard Oil ("SO," see?), Esso changed its name to Exxon when other Standard Oil spinoffs complained about the use of Esso.

Stopping to check out an old gas pump can lead to interesting tales too. I discovered a story in Edgefield County about a mule kick that killed eight people because I stopped to photograph an old gas pump. I'll share the introduction.

You can drive by a place a thousand times and be unaware of its history. Such was the case for a small country store on Highway 378 in Edgefield County. Over the years, I've passed the little store plenty of times and not once did I stop. That changed Sunday, October 13. I did pass it, but I turned around and went back, curious to see what the price of gas was on the old rusty pump.

I got out with my camera, and a classic RC Cola sign immediately distracted me. Behind it was another vintage sign advertising Camel Cigarettes. *American Pickers* would like this place, I thought. I moved closer to get a good shot. That's when a man slipped up behind me.

"If you think I'm selling those signs you're wrong."

Startled, I said, "No, I just wanted to photograph the old gas pump and the signs caught my attention."

"People try to buy them all the time."

"It's a wonder someone hasn't stolen them," I replied.

"Maybe I'll file off the nail heads," he said and then he paused. "My granddad got killed in that store."

"Robbed and shot?"

"No, a woman had him killed for $500."

And then the most incredible story unfolded, a story that goes back to 1941. The little store at the intersection of Highway 378 and Highway 430, a road that leads to Edgefield, a road known as Meeting Street, holds deep, dark secrets.

It's unlikely I'd have stumbled onto that story had I not stopped to photograph the pump at the old Timmerman store. Like the pump in Mount Carmel, the Edgefield country store pump was rusty red.

I like this old pump, too, because the penetrating smell of gasoline has given way to the sweet smell of honeysuckle. Every now and then, as I ferry across the Savannah, I detour off Highway 378 to check on this Mount Carmel survivor. I expect it to continue to age gracefully, and I expect the honeysuckle to encase this veteran of another era in green and yellow as springs come and go.

WALL DOGS' GHOST SIGNS

IKE DOGS WITH A PENCHANT for roaming, they chained themselves to a wall. Tethered to brick walls with a brush and bucket of paint in their hands, these daring artists had a mission: painting an advertisement onto the side of a building. They called themselves "wall dogs," and some claimed that they worked like dogs. I suspect they loved their work, and I am certain wall dogs' ghost signs make our world more mysterious, more beautiful.

Along forgotten byways, in small towns especially, you'll spot ghost signs, an old-fashioned advertisement painted onto a rough and unforgiving canvas, a brick wall. Ghost signs hawked products and businesses that no longer exist—Coca-Cola being an exception. The products and businesses they peddled possessed names as colorful as ghost signs were in their prime. Owl Cigars. Old Reliable Bruton's Snuff. The Creamery Café. King Midas Flour. Can't Bust 'em Overalls. Uneeda Biscuit. Ballarat Bitter. Made by Cows Milk. Mother's Bread 100% Pure. And Nightly Bile Beans. Some ads shone a light on the times, such as Clark's Café All White Staff. Exuberant American capitalism, some called these ads.

You'll see rejuvenated ghost signs, some having been preserved for nostalgic reasons. Others continue to fade, a ghostly reminder of the past. Original creators of these vintage ads—works of art—left us long ago. Their work, however, lives on.

Once upon a time, wall advertising was all the rage. Many ghost signs went up in the late 1800s on up to the Great Depression and into the 1960s. Most buildings sported commercials. Advertisements painted directly onto brick

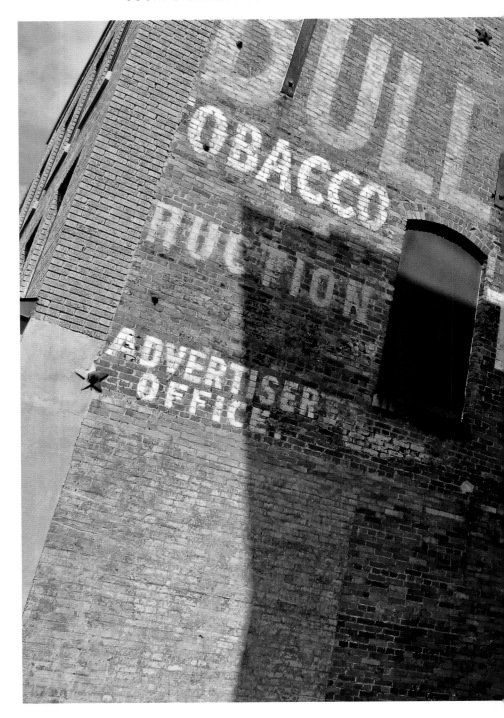

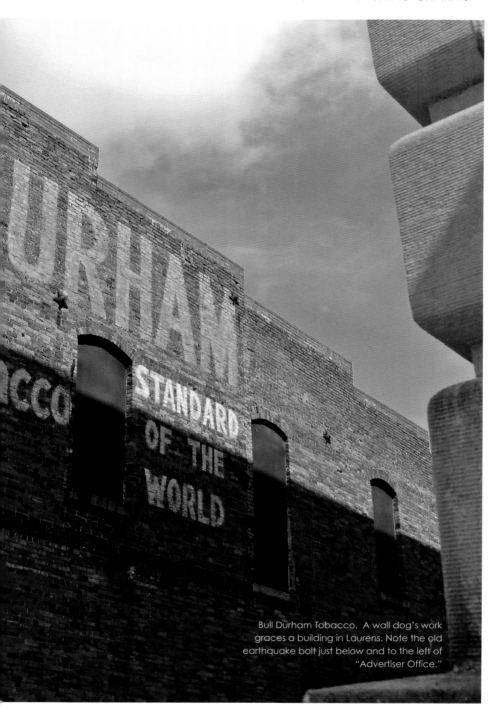

Bull Durham Tobacco. A wall dog's work graces a building in Laurens. Note the old earthquake bolt just below and to the left of "Advertiser Office."

buildings brought colorful messages to people in cities, towns and villages. Zoning and changes such as advertising on billboards led to painted brick advertisements' demise, but many survive, paint flaking away yet clinging nonetheless to the walls that have long given them a home. Lead-based house paint grips brick with tenacity, but relentless sunlight and the elements conspire to fade them. Demolitions to make way for sparkling character-starved edifices have robbed us of many ghost signs. When you come across a ghost sign, I advise you to photograph it.

Vintage sign painters were skilled artists who generally worked for one of the major sign companies. They roamed from town to town and lived an eccentric lifestyle. Owners of walls often got a perk, a smaller ad for their own business above or below the main ad. The painters mixed their own paints to exacting colors. Wall dogs used scaled drawings to transfer their designs to walls, making sure the lettering was level. Often the wall wasn't, and they saw that all elements filled the space as planned. Their exacting work survives in the hinterlands and cities, but something about small towns and ghost signs go together. When I journey through a town with a sprinkling of stoplights, I expect to see ghost signs; more often than not, I do. Bleached by sunlight and washed by rains, they do indeed look ghostly, a pale rendition of their former glory. I see, too, new murals designed to give a town a tourism boost. Don't confuse those with ghost signs. Freshly painted ads on buildings lack authenticity. Real-deal signs often promoted patent medicines, tobacco and beer.

We live in the era of garish digital billboards that give me a craving for old ghost signs. Fortunately, modern wall dogs carry on the tradition of painting on buildings, and they do so in a traditional way, including the paints they use and the way they mix them. Suspended on a platform hooked to a pulley system, they work ten to twelve hours at a time. They use levels, brushes and sketches and wear safety harnesses in their airy studio on high. They face challenges. Scale, delicate lettering, the fear of dripping paint on someone and that thing called gravity. You could say the work has its ups and downs. It's risky. They only get to break the law of gravity once.

Just once I'd love to drive into a small town, one with one stoplight at the junction of dusty roads, and enter a *Twilight Zone*–like time warp that transports me to the past. I'd like to catch sight of a Norman Rockwellesque setting where a wall dog is standing on a platform painting a hardware store's wall of old brick. He reaches down, gets his paint-splattered level and makes a mark. Here is where the words will go. Ever so carefully, he makes a white "B" and then a "U." The work progresses. When he is done, a Bull Durham

ad glistens on the brick. He lowers himself to the ground and admires his work. Then it's time to load up and travel to the next town. In the decades to come, his Bull Durham ad will age, crack, flake and fade. Like a weathered face, it'll possess character. And our wall dog? All that lead paint did him no favors. He'll end in a place called Obscurity.

Wall dogs did their thing, never meaning to leave latter-day folks charming ads. They sought highly visible locations from which their ads could solicit business, and up went their form of art. For those of us who love nostalgia, we owe wall dogs, a different breed of artist, a big thank-you. And ghost signs? Consider them a window to the past.

A TRAIN ROLLS THROUGH IT

THE FIRST TIME I HEARD of Branchville, South Carolina, I was a ticket agent at the bus station in Athens, Georgia. A passenger bought a one-way ticket to this hamlet, and I ran the white-yellow-pink carbon-paper ticket through a machine like those that once processed credit card transactions. When the call to board the bus came, the passenger got on. Never saw him again. That was forty-four years ago.

"Where is Branchville?" I wondered. Well, now I know. It's in the land of center pivot irrigation systems. It's where the land is as flat as an ironing board. It's in the realm of the crumbling tenant home. Here and there you see fields of stubble where cotton clings to stalks like lint on an old man's coat. It's down south of here, as they say, on US 21 where Highways 78 and 210 cut through it.

Back in my ticket agent days, my travels pretty much were limited to the road to Athens and back from my hometown. I wasn't worldly. I wasn't even regionally. My knowledge of the two-state region I call Georgialina wasn't anything to write home about. Not so now. Today, I travel a lot as Georgia, South Carolina and North Carolina go, and I see a lot of small towns with trains rolling through them. All seem busy—small centers of commerce. So, being the economist that I am not, I associate trains and small towns with boom times.

I came to Branchville in a roundabout way. A magazine had assigned me to write about three bona fide BBQ joints, and thus did I finally visit Branchville after selling that ticket so long ago. My actual destination was

Country roads lead to Branchville, in southern Orangeburg County, home to the world's oldest railroad junction (1828).

Smoaks, where you'll find B&D Bar-B-Que in the middle of nowhere. Just follow that tantalizing smoke.

Branchville was on my route to B&D, and it killed a theory I had been forming—that small towns with trains rolling through them prosper. Branchville seemed sleepy. Not that that is a bad thing. It has the usual things a small town has, convenience stores and such, and it also had a handsome depot that is now a museum. Maybe I just caught the town on a day when not much was happening. Or maybe my theory is flawed.

HIGH NOON IN BRANCHVILLE

I saw a handsome red caboose with bright yellow trim. On its side was the word *Southern*. Nearby were old wagons, the kind mules pulled. Nearby also were benches, empty, for no passengers were around. Dark clouds scudded overhead. It was a somber day. Still, a restaurant, the Eatery at the Depot, appealed to me. Too bad it was closed. Out back, where people could dine beneath the depot waiting area roof, there was a sign: "Good Eats." It looked like a good place. Someday I'll check it out.

Trains. I've long associated them with romantic ideals. When I was a boy, I could hear the train rolling through McCormick County from my Grandmom Poland's farmhouse across the line in Georgia. And then there was the one Amtrak trip I took back in the 1980s. "We hurtled through darkened countryside swaying side to side in a rhythmic clacking that would be our accompaniment all night. Approaching crossings, the train would sing its forlorn song: two long blasts, a short blast and a final long blast. Percussive clacking and airy weeping goes the night train anthem—how mournful in the dead of night, how lonely to those in blackened countryside lying in beds. Perhaps a few envy the travelers piercing their night. 'To what magical places do they go?'"

To Branchville I had gone.

All these things occurred to me as I wandered around Branchville. I wasn't visiting a town so much as I was visiting the past. So can you. Drive south on US Highway 21 and you'll find Branchville where Highway 78 crosses 21. An account of its history says this: "From the stagecoach to the

ABOVE The caboose once provided shelter for a train crew. Changing times have many serving as tourist attractions.

railroad to the automobile, bus and truck—that in a few words, summarizes Branchville's history." Branchville had the country's first railroad junction too. And the bus station aspect is how I first learned of this small town.

One final note. I looked for the bus station. No luck. Probably it was an old store that served double duty as a bus stop. I was hoping to see where my passenger disembarked so many years ago. In a small way, that would have completed a memory that formed when I was a much different man, a fellow who way back then had no inkling he'd someday see Branchville up close.

SALTERS

A WHISTLE-STOP KIND OF PLACE

UNINCORPORATED—a big word with small implications. If a town is unincorporated, it's small, and Salters, South Carolina, is diminutive. Tucked away behind forests off a back road, it's the kind of place you go to for a reason. I went to visit a glorious remnant of the past. I say "glorious" because there's something dignified and magnificent about Salters.

If you, like many beach-bound folk, take some back roads to the coast, you might get a chance to pay Salters a visit. Once you pass through Greeleyville and cross Highway 52, be on the lookout. Don't be like the many tourists who skirt the village as they speed down Highway 521. If they would turn onto Glad Street, they'd be glad they did. Perchance they might spot an old-timer walking the tracks who'd tell them in a wheezy voice that Salters, once upon a time, was known as Salters Station and Salters Depot. Now it's cut short: Salters.

If you are a fan of gray, weathered boards, rust-splotched tin and lonely highways, then you will like Salters and its old depot that dates back to the mid-1800s and patiently sits alongside the Atlantic Coast Line Railroad.

Growing cotton once worked pretty well here. Now men in this Williamsburg County region fell trees, as forestry is the main vocation, but the tattered old gin still stands not far from the depot. Writing in the Center for a Better South, retired editor Linda W. Brown said that "the Salters gin not only provided employment for the adults of the community, but it also was a source of recreation for the young people. One woman who grew up there remembers, 'Jumping cotton bales which were stacked at the gin for recreation.'"

"Visiting Salters, for me," said Brown, "is like stepping back to an era when people spent the afternoons sitting on their front porches watching the trains go by." She's right. It's a place where sitting provided entertainment. There's no café here; even so, it brings to mind Fannie Flagg's Whistle Stop Café. And as for that old gin, well, I stood in front of it not long ago. I tried to conjure up lean-legged women jumping bales for fun in its confines, and I saw a few screaming and laughing as they hit the cotton.

Aside from the gin and depot, another building dominates this whistle stop: the Salters Plantation House, an example of nineteenth-century domestic architecture. William Salters built the house around 1830, not long before he died in 1833. Folks have added on to the house, where a Greek Revival influence holds sway. Six stuccoed brick columns on squared brick bases once supported the rain porch, as it was known, a feature associated with eastern South Carolina and the Pee Dee. Change arrived. The columns look a bit different.

Come visit this place and its old buildings. You might think time turned its back on Salters, but that's not true. Time, I believe, just decided to mark time in a place that, in a way, became a living museum.

THE OLD HAND PUMP

"THE PUMP DON'T WORK 'cause the vandals took the handles," wrote Bob Dylan as he closed out "Subterranean Homesick Blues." Vandals have yet to get the handle of this pump, but I don't know if it works. I didn't try it. Wish I had. Let's just say that it works and that's why it didn't end up in the scrap metal pile. Let's add that if you work the handle enough, your reward will be gurgling spurts of water.

I place old hand pumps alongside windmills as ingenious, environmentally clean ways to meet needs. Once in a blue moon, I'll stumble across one out along a lesser-traveled road. You'll find one at the ruins of Sheldon Church near Yemassee on Old Sheldon Church Road.

You'll find this old pump just off Highway 23 in Ward to the right of Royal Foods. Just look for the old Union 76 gasoline sign, a bit of nostalgia itself. Find it and give the handle a try. Behind you, the Ward water tank looms large, a tub of water in the sky that put a lot of hand pumps out of business.

There was a time when building a home depended on access to water that was fairly close to the surface. That changed when electricity and drilled wells came along. Thanks to those modern conveniences, you could build a home most anywhere and lift water deep from Mother Earth's bosom. For folks out in the country, an electric pump and tank meant water was as close as the faucet—as long as they had power. An ice storm that knocked the power out for days, however, meant no water. That's not a problem with hand-pumped water.

Yep, a measure of independence comes with an old hand pump. Survivalists and people wishing to live off the grid install hand pumps. People who want a back-up water supply do too. In developing countries, hand pumps provide vital sources of water. Here in the United States, we look at them as vestiges of yesteryear, as nostalgic reminders of times gone by. Just turn a faucet and there it is—the miracle of life called water.

The old hand pump, referred to as a cistern by some, had to find water fairly close to the surface, within twenty-six feet I read. Any deeper, and it was out of reach. Hand pumps are making a comeback of sorts. You can still find suppliers who will sell you one. Some people install them as an alternate water supply. Some install them for a touch of nostalgia, and some install them as a reliable source of water. Be nice to have one out in the tomato patch. Just hang a bucket on it.

Someday I hope to discover an old home place with an outhouse, smokehouse and hand pump intact. Finding an old pump is a long shot for sure, so I'll settle for a hand-dug well like my granddad had. A stone fireplace and chimney sound good too. Life's necessities all taken care of in a simple way. No need for electricity. If I find such a place, I expect to see an old country store down the road a ways, one with a vintage gas pump and signs that *American Pickers* looks for—like Royal Crown Cola and Camel Cigarettes.

I don't know when the old pump was installed. Long ago, for sure. Maybe a dowser, ye old water witch, is part of the old pump's history. I stepped back from the pump and conjured up an old fellow in coveralls and straw hat walking around with a forked limb. "Dig here," he said as the limb bent toward the ground. The old cistern is proof positive that they dug and hit a vein of water.

Old pump and 76 gas, off Highway 23 near Ward—two rusty relics of times gone by.

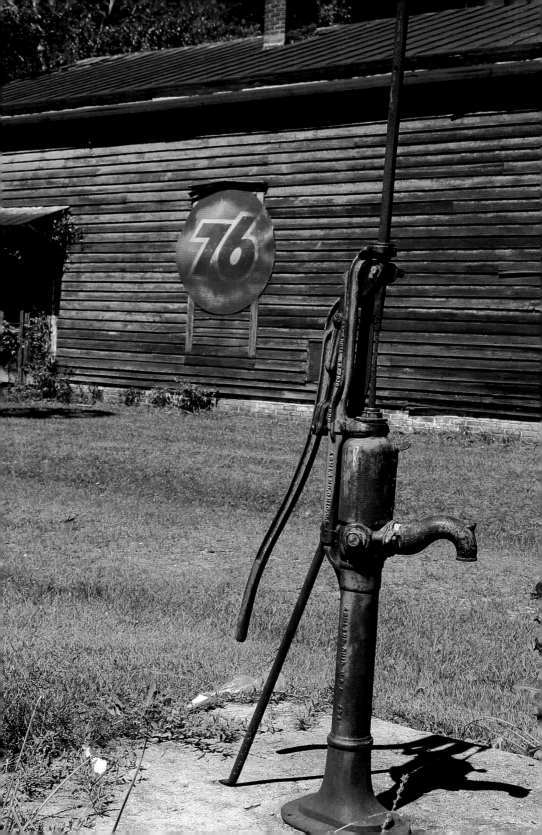

As for the old building with the Union 76 sign, it's a throwback to another era as well. If you make a drive down SC Highway 23, you'll find this scene from yesteryear in Ward. Go. For a moment or two, close your eyes and pretend you've traveled back in time. When you're ready, drive on through peach country.

WILLINGTON

A HISTORY VILLAGE

YOU KNOW WHAT I LOVE about rural byways that go nowhere? They surprise you when you least expect it. (The only way an interstate will surprise you is with a brake-grinding traffic jam, and let's be honest, that's no surprise.) One late October day, I was driving down Highway 81 in McCormick County when I happened upon Willington. What a nice surprise.

Willington has been called a village and a census-designated place. Is it small? Well, the 2010 census states that its population is 142, but it's big as history goes. You'll find Willington eleven miles north of McCormick on Highway 81, the Savannah River Scenic Highway, a road filled with pleasing views and glimpses of life in the rural South.

Willington also sits on the Nature Route of the South Carolina National Heritage Corridor, where the journey is the destination. My destination October 29 was the back roads of McCormick County. Thus it was I discovered this quaint place and, even more surprising, its history center and bookshop. Even though it was past closing time, 3:00 p.m., you know I had to stop. Fortunately, the doors were still open.

The bright red brick buildings appear to be old, and that alone intrigued me. Turns out they are. Built around 1912, the ravages of time placed the buildings on the "Eleven Most Endangered Historic Sites in SC" list. Inside the bookshop, I found shelves heavy with books. I was short for time but remember thinking, "There ought to be some real finds in here."

The Willington History Center houses archival material, including family genealogies, oral histories, historical artifacts and information about

McCormick County's historical sites. Stepping into the Willington History Center is like stepping back into a vintage country store. The shelves spirit you back in time and bring to mind an antique shop, country store and museum all rolled into one. In one section, you'll find old soap, country cured ham, old pharmaceuticals, antique bottles and a Blue Horse notebook. Remember those? A Panama straw hat, mineral oil and jars of Lance crackers and cookies are to be seen too.

Lots to see here. The old town post office, built in 1915, has been rehabilitated and is now the Daniel P. Juengst Railroad and Post Office Center. Check out the model train layout of Willington, circa 1915, and a collection of post office memorabilia. An African American one-room schoolhouse built in 1920 has been refurbished as an African American Cultural Center.

The village was named for the famous Willington Academy, founded in 1804 by Dr. Moses Waddel, later president of the University of Georgia.

Not far away is Mount Carmel, where my great-grandfather Thomas Antone Poland once lived. Born November 27, 1870, and deceased March 21, 1951, I'd like to believe that he visited here often. He would have been forty-two when these old buildings were built. If he did visit Willington, it took a family member three generations to walk in his footsteps.

You can visit too. Plan a trip to McCormick County and western South Carolina, where history is alive and thriving.

ABOVE Highway 81 takes you to Willington, a village that was once a cotton boomtown sparked by the railroad's advent in 1886. Then the boll weevil and Depression came calling.

DOWN IN CAMELLIA LAND

PART I

DATELINE I-20 WEST, FEBRUARY 11: I'm making my way to Edgefield to attend Edgefield Camellia Club's annual Camellia Tea. As soon as I take Exit 18 onto Highway 19, everything changes. I-20's bland corridor of cars, trucks and tedium gives way to thick, green cedar groves, sprawling pine-edged fields, stately avenues of oaks, an abandoned home or two, historic plantations, horses and a curious collection of what appears to be forsaken eighteen-wheelers in a powerline right-of-way.

My goal is a leisurely one: saunter around Edgefield a bit and take photos and make mental notes. I will arrange my day to end at Magnolia Dale, circa 1843, site of the first residence in Edgefield and home to the Edgefield County Historical Society. That's where the Camellia Tea will take place.

It's one of those days when it's good to be out and about. Cirrus clouds etch scrimshaw feathers into a deep blue sky. Golden daffodils shine at ground level with backdrops of green fields of rye. Explosions of camellia blooms, I'm told, will add their voices to the chromatic chorus.

My first stop is in Trenton at Darby Plantation, home to "Miz" Clarice Wise and a camellia garden some eight decades old. I ring the doorbell to no avail. That's 'cause Miz Clarice is outside. Spying me, she motions me over to the entrance of her walled camellia garden. "Daddy started it in the early 1950s," she tells me, adding that the "cold snap" got her camellias, and it's true. Freezing temperatures burned a lot of them. Still, pristine blooms live among the beautiful losers. In the blue light of winter, camellia

One of Miss Clarice's camellias, near Trenton.

blooms appear a bit subdued but nonetheless glorious. Their colors range from cherry red, lipstick pink and velvety cream to blood red, all framed by glossy green leaves.

Out front by Darby's long driveway stands a marker. A deep history lives here. Nathan Lipscomb Griffin built Darby in 1842. In 1858, son-in-law Milledge Luke Bonham acquired it. Bonham served as a congressman, governor and Confederate general and lived at Darby before the war and during Reconstruction.

Darby Plantation. It's here where a *Gone with the Wind* aside takes center stage. In 1863, Bonham sold Darby to George Trenholm, who had a dashing career as a blockade-runner. Frankly my dear, it's believed that Margaret Mitchell based Rhett Butler on Trenholm, who went on to become the Confederate treasurer. In the late nineteenth century, Walter S. Miller purchased Darby, whose widow left the property to her nephew, Douglas L. Wise, who owned the house until his death, whereupon Miz Clarice came into the picture. I photograph the historical marker and leave, catching a glimpse of one lonely daffodil, an early riser, a premature harbinger of the spring that will bring us all such joy.

INTO EDGEFIELD PROPER

For you wayfarers, sojourners, tourists and nomads heading into Edgefield on Highway 19, the Augusta Highway, take note. On the left, you'll pass the National Wild Turkey Federation, a campus of gray buildings. Its mission is to help save wildlife habitat, conserve the wild turkey and preserve a heritage of hunting.

Spiriting beneath a railroad overpass and approaching downtown, I look straight out the windshield. Over the square looms the handsome courthouse, a red brick beauty. When you get to Edgefield's square, you can't miss the large artsy turkeys standing at street corners. The NWTF and turkeys are a big deal, not just in Edgefield but in the South. You'll see two large turkeys on the porch of the Joanne T. Rainsford Discovery Center a short walk from the square. What was once an 1840 farmhouse now houses a theater, interpretative exhibits and a room dedicated to Strom Thurmond, who served in Congress until the tender age of one hundred. The late Joanne T. Rainsford succumbed to cancer tragically at an early age. She endeared herself to Edgefield for her civic work. For many years, she served as president of the historical society.

I strolled the square a bit, dropping into the near one-hundred-year-old building that houses the Billiard Parlor, a pool hall since about 1938. The "Pool Room," as it's called, reputedly serves the best hamburger you'll ever eat, reason enough to drive to Edgefield, lest you be a vegetarian. Make the drive anyway. There's the Edgefield General Store, with its old wagon now rendered into a wine rack, and Tompkins Memorial Library, home of the Old Edgefield District Genealogical Society. While there, I met a lady from McDuffie County, Georgia. She, as were others, was sorting out her past. Edgefield and genealogy are synonymous.

The Edgefield Courthouse, unlike so many others, never burned, and that scalawag Sherman never passed through here. The records down here sure do stack deep. If you have family connections to Edgefield, as others and I do, the courthouse and archives next door are where you can research your family's genealogy. For you readers unsure of your roots, here's the place to begin sorting them out.

Edgefield, going way back in time, provided a point of westward dispersion for many, and thanks to its vast records, it gets a lot of tourism based on researching ancestors. Edgefield County archivist Tricia Price Glenn will tell you that there may be millions of records here. They have been growing and growing since 1785. People who know that flock to

Edgefield to unravel their past. You've heard of eco-tourism. Well, add ancestry-tourism to the lexicon.

As you'll read in the next part, Edgefield is a happening place. So happening, in fact, that two fellows ambled into the Edgefield General Store with a freshly found intact pot made by Dave the Slave. "We got a pot for sale," they said.

"It's one of his pots, all right," said one fellow.

"But he didn't sign it," said the other.

And it was at the Old Edgefield Grille where I met Janice and Harriett. What a conversation we had. "Now don't put that in a book," they admonished me more than once.

And earlier I walked into Carolina Moon Distillery, where Martha and I cooked up a little prank on the lady at Discovery Center. Then, too, there's the reason for my journey: the Camellia Tea.

DOWN IN CAMELLIA LAND

PART II

THE EDGEFIELD GENERAL STORE is a place with something for everyone: an old-fashioned soda fountain, gourmet items and the talented services of Maine the florist. It was there, near the front door, where two fellows out of Barnwell ambled in claiming they had found a pot made by Dave the Slave. Nancy Gilliam referred them to a pottery expert around the corner. Off they went, would-be pottery peddlers, seeking fame and fortune.

I stepped into the sunshine and took stock of the square. My kinfolk walked this square. It's taken me most of my life to learn I have ancestral roots in Edgefield. For many years, I drove through Edgefield County paying it no mind. It was just a place between here and there. All that began to change when a long-lost relative read my work online and contacted me. We met in Edgefield one November Sunday a few years back. As he showed me and my cousin around town, a feeling of odd familiarity took hold. As I walk out of the Edgefield General Store, that feeling returns. I wonder just how many times long-deceased relatives stood on the very spot I stand.

A few strides to the left land me at the Tompkins Memorial Library. That's where I talk with the lady from McDuffie County, Georgia, who is sorting out her family ties. Who knows? Maybe she and I are related. I make a mental note to return to this library, which serves as the official visitors' center of Edgefield. It's said that the library averages two thousand visitors a year from forty states and several countries. You could say it carries a load,

serving as the headquarters of the Old Edgefield District Genealogical Society and South Carolina Genealogical Society. It also plays a pivotal role in the annual Southern Studies Showcase each September with a variety of speakers and events focused on historic and genealogical research. Check it out at 104 Courthouse Square.

As I leave the Tompkins Library, the two fellows who found the alleged Dave the Slave pot walk by. I can't tell if they are jubilant or disappointed. They remind me of characters from *The Andy Griffith Show*. They get into a pickup truck and head out of town. Back in Columbia, I made a phone call and learned that their pot was not one of David Drake's pots. "Dave the Slave," as he's referred to, could read and write, quite unusual for the times, and his twenty-five- to forty-gallon jugs often featured verses and couplets: "Put every bit all between / surely this jar will hold 14."

AS FINE AS ANY IN CHARLESTON

I drop in at John Kemp Antiques. John has walked up town, but Virginia graciously shows me around, pointing out gorgeous old desks (one has had a top "added on") and an ancient handgun cased in glass. She shows me a clock from London as ancient as time itself. "It still runs," she says.

You'll hear about hallmarking English silver and words like "Chippendale" here. There are great pieces to be found here, as the Kemps have been in the antique business for forty years and make frequent trips abroad to buy inventory. You'll find antiques here as fine as any in Charleston. They specialize in Early American/Federal/Empire furniture and silver. Virginia prides herself on their policy that if you purchase a piece of furniture from them, you can trade it back in any time as they stand behind the provenance of their fine pieces. Before I leave I say, "Maybe I'll bump into John around the square."

She smiles, and knowing I have never met the man, says, "John has a ponytail, and he'll be sorry he missed you."

Driving away, I look at the fine house, Willow Hill (post-1822), they live and work in. That's how things used to be. The Kemps, having restored the home to its original Adam-style façade, found the perfect place for their antique business.

At Carolina Moon Distillery, Martha MacDonald asks if I plan to visit the Discovery Center. I already have it on my agenda, but then she says, "My

Step inside for the best hamburger in the world, so they say.

friend, Ellie, a spirited redhead, works there." Okay, I think, Ellie has no idea who I am or that I am about to pay her a visit. Time for some tomfoolery.

At the Discovery Center, I walk onto the porch between two large artsy turkeys and open the door. The Discovery Center is quiet. Ellie, sitting at her desk, looks up. "Well it's good to see you after all these years," I tell her. I get a confused look. "Can you believe it's me? I know my hair is different now, but it's me at last." I get nothing but a stare. "I mean, the way we parted wasn't the best, you know, but here I am."

More bewilderment. She says nothing. A long pause settles in. "Ellie Glaze," I say, "now you know you remember me. How could you forget all the times we spent together?"

"I know you?"

"Sure. Of course that was a long time ago…a long time ago."

Now, I have a tendency to hit the nail one time too many and dent the wood. Ellie squirms a bit, and I detect a degree of vexation. Time to come clean. "My name is Tom and your friend Martha sent me here. I'm here to write a story on Edgefield. I'm just messing with you."

We share a laugh or two, and a relieved Ellie shows me around the Discovery Center, which now has a fine theater as part of its offerings. The center began life as the Captain James Miller House, circa 1840. Located

near Trenton, it was moved to Edgefield in 1992 by the Edgefield Historical Society as part of the Joanne T. Rainsford Heritage Center of the South Carolina Heritage Corridor. You'll see some fine examples of Edgefield pottery here, a room devoted to Strom Thurmond and more, including a relieved Ellie.

With time to kill, I drop into the Billiard Parlor and look around. My kind of place. I head downhill and to the right to the Old Edgefield Grill for shrimp and grits (the restaurant's recipe was featured in *Southern Living*). Lunch proved scrumptious, but the conversation with Harriett and Janice was even better. Much of it centered on Strom Thurmond's, shall we say, colorful past. Some whispering commenced. "Now don't put that in a book!" We talked about the infamous "mule kick that killed eight people" too.

This Victorian-style brick home, built in 1906, provides great ambience, and Strom, come to think of it, was just four years old when the home went up.

ON TO THE TEA

The raison d'être, of course, for my variegated journey to Edgefield is the Camellia Tea. Now, I'm social but not a socialite, so I'm venturing into uncharted waters. The tea takes place at Magnolia Dale on 320 Norris Street. This home sits on venerated ground, the 1762 site of Edgefield's first residence. Magnolia Dale itself, circa 1843, possesses a degree of notoriety. Alfred J. Norris, a distinguished Edgefield lawyer and businessman, purchased the property in 1873. Two years later, his daughter, Mamie Norris, came into the world here. She would go on to marry James Hammond Tillman, who would become lieutenant governor of South Carolina and a player in South Carolina's "Crime of the Century."

Tillman was elected lieutenant governor in 1900 and ran for governor in 1902 (Strom's birth year). After a grueling campaign in which Narciso Gener Gonzales, the editor of *The State* newspaper, repeatedly attacked him, Tillman ascended to notoriety for shooting Gonzales at point-blank range in Columbia. South Carolina's most celebrated newspaper editor was dead. Why? Because of the unflattering things Gonzalez published about Tillman in the newspaper. (Tillman would sure have a hard time in today's social media world.) The story's political and complex, but the

upshot is that Tillman got away with it. The general consensus is that the jury was rigged and highly partisan. Although Tillman shot Gonzales in broad daylight before lots of eyewitnesses, he was acquitted on a weak self-defense theory. The jury believed that Tillman was right in taking justice into his own hands, as Gonzales had waged a newspaper crusade against him. That campaign helped defeat Tillman in the 1902 South Carolina governor's race.

ABOVE The Edgefield Camellia Tea commences—silver service sets, annotated blossoms and elegance in general.

Political feuds aside, Magnolia Dale was given to the Edgefield County Historical Society in 1960 for use as its headquarters. Adored Edgefieldian Broadus M. Turner, upon his 2006 passing, left a significant bequest to the historical society for restoring Magnolia Dale.

The portraits of Arthur and Margaret Simkins hang there. Simkins is referred to as the "Father of Edgefield" because he donated land for the first courthouse and public square. Other family portraits, the Blockers, and notable things distinguish this grand home. As I walk up to it, I sense the history that oozes from the grounds and seeps from the fine old oaks here. If only aged brick walkways could talk. I check my watch—2:59 p.m. Ladies and a few gentlemen walk toward the entrance, where a black-clad Jayne Rainsford greets people.

The Edgefield Camellia Club Tea, part of the Great Gardens of America Preservation Alliance, puts on a fine tea. The tea—from three o'clock to five o'clock—makes for a great way to spend the afternoon. Finery and elegance refine two hours otherwise devoted to a chilled winter afternoon. It's free, elegant, open to the public, colorful and festive. Tea from the Charleston Tea Plantation and beautiful blooms, properly annotated, bring the classic South alive. Sandwiches, sweets and punch are in abundance. Polished silver tea sets gleam as window light strikes them. Faces from the past preserved in oil on canvas gaze at participants. The women are beautiful, the men appreciative. As Miz Clarice pours tea, medleys and trickles of conversation blend into a pleasant river of talk. It is, quite simply, an occasion. As the Edgefield Camellia Club so rightly puts it, "The lovely mid-winter afternoon will be completed amidst a backdrop of chamber music, provided by local musicians," and indeed it is. Hostesses with very southern names, Lady and Henrietta, greet visitors, camellia authorities and the curious. All in all, it makes for an intriguing mélange.

The tea traces its origin to 1949, when Edgefield was well known as a premier camellia growing area. Back then, blooms beautified the home of Joe and Chrissie Holland at their "Camellia Tea." Edgefield, you see, has long grown some of the oldest gardens in South Carolina, and the camellia's been a favorite here since the early 1800s when the first specimens came to Edgefield. Next winter/spring, do yourself a favor. Drive around Edgefield and enjoy the results of a century of plantings.

I enjoyed my time in Miz Clarice's camellia garden, although she and I talked only briefly. A retired schoolteacher, she's very active in the historical society. Her father's camellias make for a great attraction at Darby, but much more than camellias grow in Edgefield County. My fondness for

the town and county grows as well. People here are friendly and gracious; besides, my father's folks, the Busseys and the Searles, came from the Red Oak Grove community, and my paternal grandmother's folks, the Blanchards, came from Edgefield as well.

My February day in Edgefield made for a good cutting, about six leaf nodes back at a slant. From this cutting, other beautiful days are sure to grow down in Camellia Land.

THE MORTGAGE LIFTER

I WAS ON THE ROAD running down a story about land, a farmhouse and tomatoes—a story of war, old ways and survivors. On a hot, humid July morning, I abandoned I-20 for Longs Pond Road and after a back road or two arrived at a farmhouse near the Boiling Springs community. Two huge blackjack oaks stood out front. Out back, a handsome, clapboard smokehouse looked lonely, its fellow outbuildings long gone. "We tore down the old cow barn in the summer of 2007," said Derrick Gunter, the owner of this sandy and historic acreage.

Derrick grows heirloom tomatoes here in ancient sea bottom sands, and he knows his history. Those trees of the Old South, blackjack oaks, never get much size to them, but these did. Derrick believes they may be the oldest blackjacks in the country. About thirty yards past the blackjacks' shadows, a low spot runs along Derrick's property line on across Caulks Ferry Road. The blackjacks were standing when Sherman and his boys came through on the way to Columbia. Right near those trees Sherman and his troops got bogged down in a quagmire. The Union troops offloaded cannonballs and Minié balls to lighten their load and better get through the morass. Derrick's grandfather found a cannonball and "a shoe box full of Minié balls" alongside the road, a story that tells you how much better supplied the North was than the South.

When housing construction exploded after World War II, the vast majority of homes were built of brick. The 1951 farmhouse, with its German siding, is probably the last true farmhouse built in South Carolina. Derrick began

to work on the old home, whose interior sports handsome cypress tongue-and-groove paneling and real hardwood floors. The main room's lacquer caramelized when creosote in the chimney blazed up, the chimney roaring like a train barreling down the track.

The folks who owned the farmhouse came up through the Depression. "They didn't throw anything away," said Derrick. "I threw away three thousand ties that wrapped loaves of bread." Derrick and his dad had to make seven trips hauling off two to three thousand Duke's Mayonnaise and peanut butter jars. They found a 1920 receipt from Georgia for the pecan trees growing out back, $6.50 per tree.

I knew why they held on to things. My granddad grew up in the Depression. "Keep something seven years, and you'll find a new use for it," he said more than once.

ABOVE Tasting far better than they look, these heirloom tomatoes matured a stone's throw from where Sherman marched in along a back road in Lexington County hinterlands.

Derrick's dad gifted him some land, and that led to a decision of sorts. Derrick teaches U.S. history at a high school in Lexington County. He has his summers free. His mom said, "You've got all that time off in the summer. Why don't you clear the land and grow peanuts?" He cleared it. The land was a jungle, said Derrick.

Then his dad passed along some sage advice. "Don't grow peanuts. It's a lot of work and will drive you crazy. Grow tomatoes," he said, remembering a Russian heirloom tomato a neighbor up the road had brought them. Derrick knew the tomato his dad was referring to. He had made a sandwich from it. "Best tomato I've ever eaten."

That Russian heirloom? It's called a "Black from Tula." It's a big "black" tomato with three- to four-inch, slightly flattened, oblate, dark-brown to purple fruit. It has deep green shoulders. Its flavor is heavenly, rich and slightly salty, with a smoky-fruit flavor. Another popular heirloom is the Marion, developed by the Clemson Extension Service in 1963. "Old-timers love it," said Derrick.

Derrick started out with twenty plants, doing a test run with eight varieties. Four failed, but four did well. Today, Derrick grows mainline varieties with names as colorful as they are. Cherokee Purple, Black Krim (Crimean), German Johnson, a pink tomato and perhaps the most colorful name of all: Radiator Charlie's Mortgage Lifter.

"Radiator Charlie," said Derrick, "owned land. That was the only thing he had. He had ethics and common sense but no education. He had will power and made a success of himself. As they say, they don't make men like that anymore."

In the early 1930s, Marshall Cletis Byles was going through a tough time in his hometown of Logan, West Virginia. He ran a small repair shop at the bottom of a mountain famous for fixing trucks that overheated making the long grade up, thus the moniker "Radiator Charlie." The Great Depression was making its presence known, and Byles decided to develop a large tomato families could feast on. Although he had no training in plants, he knew what he liked. He started with a German Johnson, Beefsteak, an unknown Italian variety and an unknown English variety. He grew plants from each variety and planted three Beefsteaks, three of the Italian variety and three of the English variety in a circle. In the center, he planted the German Johnson.

Using a baby syringe, he cross-pollinated the German Johnson with pollen from nine other plants in the circle. He saved the seeds and planted them the following year. He selected the best seedlings and planted them

in the middle of a circle, surrounded by the other seedlings. He repeated this strategy for six years, cross-pollinating the strongest plants in the center with pollen from plants in the circle. Figuring he had a pretty good tomato, he sold the seedlings for one dollar each, a nice sum in the 1940s. People would drive hundreds of miles to buy his seeds, and here's why. Red and pink Mortgage Lifters rank among the more flavorful heirloom tomatoes. They average two to four pounds, bearing meaty fruit in about eighty days. Crops prove abundant and disease resistant and yield until frost kills the plant.

Most heirlooms trace their heritage to the mountains of Tennessee, North Carolina, Kentucky, Virginia, West Virginia and Ohio. Yes, Ohio. They do well there because of the climate. Down here, heat and humidity are heirlooms' enemies. Derrick's do well, he says, because he nurtures them.

Restaurants use his heirloom tomatoes mainly as appetizers and salads, marinated and Caprese—a salad consisting of Italian salad, fresh mozzarella, tomatoes and basil, seasoned with salt and olive oil. It's fabulous and easy on the eyes. The restaurants make tomato pies with his heirlooms too.

In the spring, Derrick puts in twenty hours a week. He digs holes, plants and lays down mulch. He prefers rye or wheat straw. Such mulch cuts down on weeds. He gets his mulch from Stanley Shumpert, Lexington County's last dairy farmer and his uncle.

Isolating tomatoes can reduce cross-pollination, but wind and bees will still cross-pollinate them. Tomatoes are self-pollinators. Each plant has both sexes needed for pollination.

He grows plants organically, although he points out that he isn't "certified organic." He uses fish fertilizer on the plants. With the heavy lifting behind him, Derrick works six and a half hours a week during the growing season. He plants them in water with a touch of bleach to kill any pathogens present. A week before Valentine's Day, he puts the seeds in grow soil beneath grow lights. "After a month, they go into bigger pots," said Derrick. "The first of April they can go into the soil."

Derrick plants one variety per row. "I go to the middle of the row and pick out the biggest, healthiest tomatoes for seeds. Once he collects the seeds, he puts them in a cup of water in a jar. He shakes it to break up the gel that encases and protects the seeds. The next step is to place the seeds on paper towels to dry out. When they're good and dry, into the refrigerator they go until planting time.

He plants marigolds as a natural pesticide for nematodes. Marigolds deliver other bonuses, as they attract wasps as pollinators and repel deer.

One year, students from Pelion High School's Agribusiness Center started Derrick's Seeds under the supervision of Frank R. Stover Jr. and Tommy Harmon. "I owe them a big thanks," said Derrick.

"An heirloom tomato," said Derrick, "is a heritage variety that has been lost to hybridization that's red, round, 'perfect' and tasteless." This prompts Derrick to quote the late Andy Rooney: "The federal government has sponsored research that has produced a tomato that is perfect in every respect, except that you can't eat it."

Derrick made a good decision when he decided to plant heirloom tomatoes and not peanuts. Consider him a bit of a preservationist. "The benefit of the heirloom is remembering the past and securing the future. The seed will be the same plant next year. When you're dead and gone, your family can enjoy the exact same thing you enjoyed. By preserving our heritage produce in a fast-changing world, we give others a never-changing world—something that stands the test of time."

DERRICK GUNTER'S TOMATO SANDWICH RECIPE

white Sunbeam bread
Duke's mayonnaise only
any fully ripe pink or black or mixture heirloom tomato, sliced
salt and pepper
dry beef

THAT TANTALIZING SMOKE

A BONA FIDE BARBECUE JOINT should be down a back road way out in the country. It's best if it isn't open seven days a week because people need to suffer a bit. They need to crave the banquet to come. Moreover, a bona fide barbecue joint needs to sit in countryside, where you can see smoke rising from hog drippings hitting magma-red coals. A bona fide barbecue joint should issue an intoxicating two-hundred-proof smoky bouquet with primeval roots. BBQ, bar-b-cue or barbecue—just don't call it "cue"—set our DNA ablaze when lightning sparked woods afire and early man caught the scent of burnt hog. Well, that's one theory. However barbecue came to be, people love putting meat to a flame, for there's something about the commingling of meat and smoke. Of his uncle's smokehouse, author Harry Crews wrote, "From it came the sweetest smoke a man was ever to smell."

Smoke and meat. It'll make you ravenous. You can savor that intoxicating fragrance at three bona fide barbecue establishments in South Carolina, all along back roads.

SWEATMAN'S BBQ

At 1427 Eutaw Road in Holly Hill stands a wooden-shingled farmhouse with a rusty tin roof and a handsome oak out front. Come Fridays and Saturdays,

Five steps up and past the sacrificial cement pig greeter take you into a barbecue shrine, Sweatman's.

you can dine here on fine barbecue. Is it good? Jonah Wolpert has a succinct answer: "The best you'll ever eat."

If you like to spice your food with a little history, Sweatman's is your kind of place. The farmhouse was built in the 1800s and was part of a ten-thousand-acre cotton plantation, according to Karl Parker. Its destiny was to become a barbecue shrine.

Mr. and Mrs. Harold Sweatman—locals know them as Bub and Margie—opened a small barbecue place in Holly Hill when Ike was president, 1959. When they closed that location, they limited their cooking to family gatherings in an old dairy a few yards from their home. The hankering to operate a barbecue restaurant just wouldn't go away, and the Sweatmans found themselves in business again in 1977, when they purchased the old farmhouse. For more than three decades, they served up great barbecue. When they retired, Mark Behr bought the business. He knew a good thing when he saw it, and besides, he was a fan. The Behrs grew up eating Sweatman's barbecue.

Behr kept the recipes and uses veteran cook Douglas "Bubby" Oliver in a consulting capacity to keep the cooking end in place. "Gon' cook seven hogs tonight," he says as he jams a shovel into red-gold coals. Oliver says hickory, oak and pecan give their barbecue flavor. Whole hogs cook over hot coals for

twelve to fourteen hours, basted continuously with a secret mustard-based sauce. They separate pulled pork into two pans: charred "outside meat" with more intense smoke flavor and flavorful "inside meat."

I asked Oliver how many people they feed a weekend. "Ah man, got to be over a couple thousand." However many come, they leave happy thanks to the all-you-can-eat specials, BBQ sandwiches, plates and a full take-out menu complete with barbecued chicken and side items that include baked beans, mac and cheese, green beans and rice and hash.

You can find Sweatman's down a lovely country highway. When you go, don't miss the statue of the pig out front that wears a chef's toque. That pig, along with the fragrant smell, tells you that you are in for a treat.

B&D BAR-B-QUE

At 17245 Hunters Chapel Road near Smoaks, you'll find a barbecue place in the Little Swamp Community. Some say it's in the middle of nowhere. Go there, however, and you'll be somewhere all right—in the middle of some good eating.

A big sandy parking lot fronts B&D, and a lot of tires track that sand. It's rustic out here. Something about seeing a tractor and farm equipment close by feels right. A split-rail fence reinforces the feeling that you are at an authentic barbecue joint. You can thank Bobby and Dixie George for some fabulous barbecue. Some two decades ago, Bobby and Dixie chose to leave farming behind. The idea of setting up a barbecue joint appealed to them. After all, barbecue is in the southerner's DNA, and their community was rich in barbecue knowledge. Today, the people line up come Saturday afternoons and evenings. People fill the seats, as others queue up for take-out orders by the pound.

What appeals to people is the savory barbecue. If you're a fan of a heavy tomato sauce, this place will suit you to a T. They cook only the hams, and they make a very good hash from the shanks. Sides are minimal. A mammoth exhaust fan pours that fragrant smoke into the air, and the people come. As Ms. Dixie put it, "Around here barbecue is a community enterprise."

Lakeethia Hallman Smalls would agree with Ms. Dixie. Smalls says it's "the best barbecue in the Lowcountry." She appreciates what good food means to the area. "Living in a small town sometimes when you want a bite to eat, you don't feel like driving far when you want a tasty treat. You make a

B&D run!" Smalls says their food is awesome and the prices even better, and the atmosphere is friendly. "It's a place where when you hit the front door you feel welcome." Smalls adds that Mr. Bobby and Ms. Dixie and their daughter run a jam-up establishment. "My husband just wants them to add one thing to the menu and that's BBQ chicken."

B&D dishes out a distinctive heavy tomato sauce barbecue. How good is it? A huge sign on the end of a spacious red metal building proclaims that B&D "Serves the Best…Dixie-licious!" Stop by and see for yourself.

SCOTT'S VARIETY STORE

A famous blues tune goes "I went down to the crossroads, fell down on my knees." Go down to where Hemingway Highway and Highway 261 intersect and get on your knees and thank a barbecue place that looks and sounds like a general store for fine eating: Scott's Bar-B-Que, 2734 Hemingway Highway.

Ella and Roosevelt "Rosie" Scott brought that tantalizing smoke to Hemingway in 1972. Today, they sell pulled pork, two types of skins and smoked barbecue chicken, as well as a smoked barbecue ribeye steak. You can get a half and whole pit-cooked hog. The variety store sells watermelons, sweet potatoes, pecans, chips and locally made syrup, among other items. As for barbecued hog, they cook ten to twelve hogs a night and slather one of the spiciest vinegar sauces you'll ever taste all over them.

The barbecue world is rife with stories of secret sauces and cooking methods handed down by family members for a reason. There's something to that. Rosie's uncle taught him how best to slow-cook whole hogs over a wood-burning pit. After designing his own pits for maximum success, Rosie devoted himself to serving authentic barbecue that draws accolades. Its essence comes down to passion. In the Scotts' own words, "We love what we do. We built our own wood-burning pits to slow cook the whole hog overnight. Come morning, we're ready to sell our mouth-watering bar-b-que with a side of skins and our secret family sauce."

Scott's tantalizing smoke even made it into the *New York Times*, where John T. Edge wrote, "For aficionados in search of ever-elusive authenticity, Scott's offers all the rural tropes of a signal American barbecue joint.…The crowd that Saturday afternoon was typical: Half black and half white, half locals and half pilgrims."

Down South barbecue possesses a mystique. When it comes to that smoky meat, that addictive flavor, folks love to speculate about secret ingredients and "tricks of the trade." Great barbecue does have a classified ingredient, and if you know where to look, behind a door or in an outbuilding, you'll spot the secret: the cook, an artist with knowledge, technique and years of experience. It's a sure-fire recipe for success, and Sweatman's, B&D and Scott's understand that. To that they add consistency, continuity and originality. As it all comes together, smoke signals rise into the Palmetto sky, and people get the message. They come by the droves, mesmerized, as it were, by that tantalizing smoke somewhere along a back road.

FROM A BACK ROAD TO
BACKWATERS

Dateline Georgetown County, South Carolina, September 7, 2016—
Backwater bound, I stood at the dead-end of South Island Road in searing heat. Waiting on a ferry. Standing in a roasting sun can evaporate resolve, but not mine. It was as hot as the hinges of…well, you know, and especially so where the continent runs into the sea, but heat be damned. I was about to cross the Intracoastal Waterway and set foot on primitive South Island. First time.

As I waited for the ferry to pluck me from the mainland, the month of sapphires showed no mercy. The water reflected heat and the glittery Big Ditch morphed into a rogue solar farm, but I didn't care. The scent of pluff mud, salt and sea jacked me up for adventure.

The ferry approaches and I gather my gear. Onto the ferry I go. It backs, turns and docks on the other side, a physical distance of mere yards. In time, it goes back decades.

I was moments from touring the Tom Yawkey Wildlife Center's South Island, a remote place. It's isolated and peaceful, so "backwater" fits. The center itself sprawls over twenty-four thousand acres. When you're slap dab in the middle of South Island's marshes, you grasp what "vastness" means. Gazing across all those marshes and creeks, you feel like a speck. Cast your eyes to the far horizon, and a shimmering mirage-like line marks where sky meets land.

For me, the day provided a bit of déjà vu. Our guide was Jim Lee of the South Carolina Department of Natural Resources, my one-time employer. Throughout the day, I heard names familiar, one annoyingly so. But what mattered was what we were about to do: explore a large, remote barrier island rife with wildlife, a plant found nowhere else, gators and more waterfowl than I've seen anywhere. I would see things few people see, including a grassy area where Ty Cobb once played baseball.

After Lee's orientation using maps and visuals of how coastal dynamics shift islands around, I boarded the tour bus. As soon as we pulled out, horseflies as big as cicadas and ravenous deerflies pelted the windows like hail. They smelled blood. Each time the door opened, in they flew, and soon we were slapping one another, killing winged assassins.

SOUTH ISLAND BOUND

To get to the island, you leave Highway 17, the Ocean Highway, for South Island Road, and the farther you drive down South Island Road the fewer homes you pass and the more isolated you feel. It's a road that dead-ends at a ferry, a step back to the days when cars had no bridges to cross.

The ferry took us to the island, and at the orientation center, Lee, an experienced guide and local fellow, recounted man's history and the natural history of this place where more than a little breathing room exists. On South Island, we saw no asphalt, no concrete. Instead, we saw thick carpets of duckweed that create the impression you can walk on water here. As Jim drove and talked, a bobcat bolted across a sandy lane. Later, a deer crossed the road and leaped into brambles. Along the edge of an old rice field, juvenile alligators cruised through aquatic vegetation, and one kicked into high gear to snag a dragonfly that landed close by. As a bald eagle wheeled overhead, an osprey folded its wings and plummeted into the water. I couldn't tell if it came up empty or had a fish too small to see.

White ibises, cormorants and herons dotted broad stretches of green marshes, and more great blue herons stalked the shallows than I've seen anywhere, and that's saying something. Wildlife was making a living wherever you looked.

Jim stopped the bus to pick up a pink feather, lost by a roseate spoonbill, the only pink bird you'll see in the South. Feathers aplenty here and an amazing thing—zero litter, save a Mylar birthday balloon that had fallen to

the island. Think about that the next time you buy helium-filled birthday balloons. They'll end up somewhere.

The island exhibits evidence of man's lust to colonize places. Ruins of a home modeled after a Frank Lloyd Wright design remain. Its demise is a convoluted tale. The Phelpses, relatives of a private owner who long held land here, lived in it. You'll find sparse remnants of an old rice mill and Tom Yawkey's dwellings, among them "Mobile Chateau," a luxurious forerunner to today's mobile homes. When Yawkey's island home burned, he had a temporary mobile home set up on the island, and though a millionaire, he lived in it the rest of his life, from 1957 to 1976.

You'll see, too, outbuildings painted black during World War II to avoid detection by German submariners. To this day, guides refer to the area as "Blackout." Should you ever make this back road backwater journey, stand in the midst of "Blackout" and conjure up a U-boat surfacing in front of you. *Achtung.*

SOUTH AND NORTH ISLAND owe their non-developed fate to Tom Yawkey, who inherited vast coastal landholdings from an uncle. Yawkey, who spent winters near Georgetown, loved the outdoors and loved watching birds, so much so that he taught himself the rigors of being an amateur ornithologist.

As the years rolled by, he added to his holdings and preserved the land for wildlife. He carefully managed his land using his own conservation practices. A pristine area reserved for waterfowl, turtles, alligators and other wildlife resulted. Today, the Tom Yawkey Wildlife Center shelters marshes, wetlands, forests and beaches. Hundreds of species of wildlife live here and migratory birds, eagles, osprey, falcons, alligators and endangered species find sanctuary here. The beaches provide excellent nesting grounds for loggerhead sea turtles. Thank Tom Yawkey for all this vastness and richness.

Although he and his wife lived here in near isolation, he had a city longing. This cum laude graduate of Yale University with a degree in engineering loved baseball, so much so that he purchased the Boston Red Sox in 1933. At South Island, he used a radio to keep stats on his team and never failed to listen to the games. One day, the radio station failed to broadcast his game. After he learned that the station had been bought and would no longer carry his team's games, he bought the radio station (and others) and returned his games to the air.

Yawkey died in 1976, but his legacy lives on among marsh grasses, birds, gators and ecosystems that refresh the natural world. Yes, it's hot and buggy, but I love this primitive place. How primitive? Well, you have to bring your

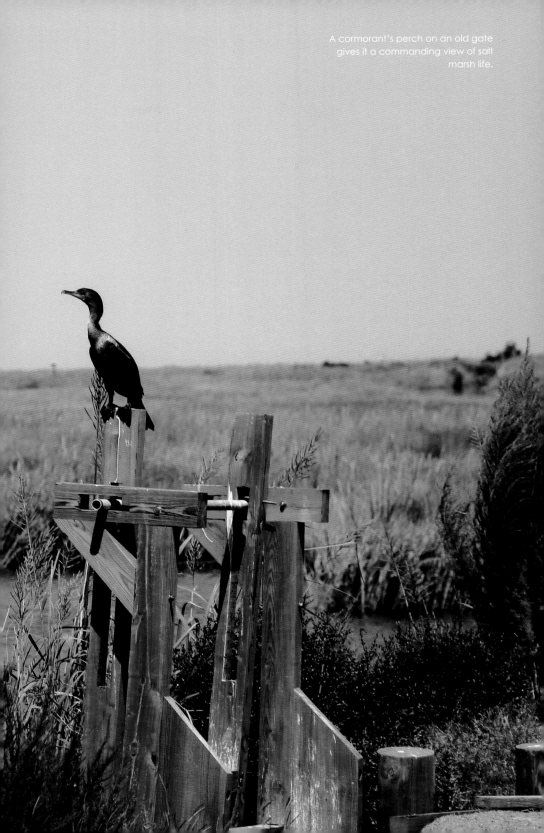
A cormorant's perch on an old gate gives it a commanding view of salt marsh life.

own water and food. It's not handicap accessible either, so that ought to tell you just how wild it is in this era of legal mandates. You could say nature rules here, and you'd be right. Here the air seems fresher and the landscape possesses a haunted beauty. Few buildings blight it. Breathe a sigh of relief that man can't get his hands on every square inch of island property he covets. If he could, where would we go to behold nature at her wildest?

NORTH ISLAND

DATELINE GEORGETOWN COUNTY, SOUTH CAROLINA, AUGUST 15, 2017—Not quite a year later, I return to South Island Road and Carolina backwaters. The destination? The Tom Yawkey Center's North Island. To get to North Island, I again have to drive down South Island Road and take the ferry to meet guide Jim Lee in the briefing room. I did just that on a hot August morning beneath a sky salted with puffy white clouds.

During our briefing, Lee took a call from a man I had interviewed earlier in the week, the "Alligator Man." In these parts, you can't talk wildlife without the name of Phil Wilkinson coming up. During my Sunday night interview with Wilkinson, I had asked him if it were true that a gator could outrun a quarter horse for forty yards.

"Bullshit," he said. "I can outrun a gator, but I sure can't outrun a horse." It would not be the last colorful pronouncement from Wilkinson, who told me, "I grew up in the Santee Delta. I've been lucky all the way." Indeed, Lady Luck smiled on this man, who was fortunate enough to work in the region where he grew up catching gators and studying eastern brown pelicans.

Following our briefing, Jim Lee had us board a Boston whaler. Bugs weren't a problem, but we had to wear lifejackets per South Carolina Department of Natural Resources regulations. Wearing them was as hot as a night in a south Georgia jail.

As we headed toward a destination with the North Island lighthouse, I thought of all the times Wilkinson must have coursed over these waters. Lee stopped here and there to point out historic sites: an old Confederate fort and Tom Yawkey's abandoned boathouse, nothing but its rafters and roof visible, like an upside down beached ship. We saw, too, an abandoned Coast Guard station. We saw an island of spoils dredged from Winyah Bay.

As we crossed wide Winyah Bay, a ten-foot alligator crossed the chop one hundred yards in front of us. Again I thought of Wilkinson, wondering if he

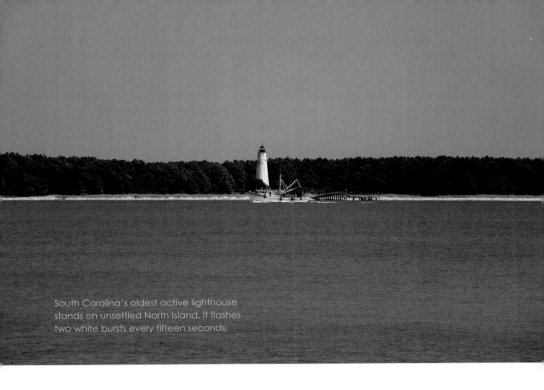

South Carolina's oldest active lighthouse stands on unsettled North Island. It flashes two white bursts every fifteen seconds.

had tagged that very gator himself. A woman asked Lee to get closer to the gator, but he paid her no mind. The gator made it to shore after a long swim across Winyah Bay.

We, too, made shore, on North Island, the island where Lafayette first set foot on North America. It was here that Lee discussed gators and brought up the Alligator Man, Phil Wilkinson. Lee said that Wilkinson's knowledge of gators was vast, and it should be. Wilkinson, who remained active after retiring from the South Carolina Department of Natural Resources, continues to study gators. He has records going back thirty-seven years on gators, and he's seen it all, including a gator that ripped the fender off a truck. "A gator," says Wilkinson, "can live ninety years if it is in good shape." (There's a lesson in that for us too.)

Images of a big gator destroying a truck swirled in my mind as we docked near the North Island lighthouse. We put ashore, removed the sweat-inducing lifejackets and headed toward the lighthouse, built in 1811. After Lee's advice on watching our feet—a mean cactus and snakes—we climbed the white-painted brick lighthouse. It's an easy climb—if you don't mind spiders, including black widows. It's South Carolina's oldest continuously active lighthouse, and it gets its power from the sun. Solar-charged batteries fire it up. So here, you see this blending of old and new technologies.

Charleston contractors Thomas Walker and James Evans built the lighthouse employing slave labor, it's said. It's solid as rock and with good reason. It's made of iron, brick and stone. Bricks at the base are five feet thick, and the circular steps are cut from rock. The bottom of the steps bring to mind stalactites, albeit short ones.

The old federally operated lighthouse, one of two that remain in South Carolina, possesses quite a history. It served as an encampment for soldiers during the War of 1812 and as a refuge when the 1822 hurricane destroyed most dwellings in the area. Confederate soldiers used it as a lookout, but in time it fell into Union hands. None of these things were on my mind as we climbed the 124 steps to the top. It was dark, fairly hot, and there was a winding route to the top, the domain of spider webs. The light plane itself is eighty-five feet.

When we climbed up through the trapdoor into the light room itself and stepped out onto the iron catwalk, we had a spectacular view. The panorama included Winyah Bay, North Island, the International Paper Mill plant and a Coast Guard vessel. Behind us, far across a line of maritime forest, lay the Atlantic. Directly below, we saw an abandoned Coast Guard outpost, now the realm of wasp and bird nests.

A Coast Guard vessel in Winyah Bay stands by to perform duties that include rescuing boaters from themselves.

History and spectacular views didn't occupy me. I got to thinking about all the years of salt air and how it rusts iron. That made me a tad nervous, queasy even, about all of us standing on the catwalk. I retreated to the light room, but it was mighty hot. I decided to take my chances with gravity and rejoined the folks on the catwalk. I wasn't superstitious, but I had read beforehand that some bad luck struck men who worked at the lighthouse. In December 1915, Charles F. Johnson, the keeper on South Island, shot himself. Johnson had been suffering from tuberculosis of the throat and had been unable to eat. He had threatened to kill himself several times and just days before had picked out his casket. In 1933, head keeper Joseph W. Grisillo was found dead in a chair inside the keeper's dwelling. The coroner ruled that Grisillo died of natural causes.

Keeper Gabriel Jackson, who replaced Grisillo as head keeper in 1933, was serving with assistant keeper George C. Ellis. Then, on November 5, 1938, an explosion rocked the boat the men were traveling in on Winyah Bay. Both men jumped overboard. Ellis, who couldn't swim, clung to a wood plank but lost his hold and drowned, never to be seen again. A towboat out of Georgetown picked Jackson up two hours later; he had suffered burns to more than 90 percent of his body. One month later, he returned to the lighthouse.

All that bad karma made me glad when we descended to the ground. We boarded the whaler and donned lifejackets, and on the way back, Lee spotted a bald eagle perched in a cypress. Its head gleamed like snow. We drifted ever closer to get photos, but the eagle would have none of that. Off it flew. And soon off we went, our tour complete. But what a tour it had been. Just as we docked, a dolphin surfaced as if to say farewell. And to think that all of this could have been lost to development.

Where else can you see historic forts, remnants of the rice culture, the state's oldest lighthouse, places a man who owned a baseball team loved, bald eagles, alligators and more? Where else can you step onto an island as Marquis de Lafayette did? Where else can you enjoy a place the Alligator Man influenced Tom Yawkey to donate to South Carolina?

Down a back road to back waters. That's where.

SEARCHING FOR PROMISED LAND

I SAW IT ON A MAP and decided to go there. My destination? Promised Land and a place called Obscurity. Day one of my two-day, 410-mile back road excursion broke heavy with humidity. A sweltering day lay ahead. Mirages, dust devils and heat apparitions would be my companions on this journey in search of seldom-seen sights.

I made my way to SC State Highway 34 to Silverstreet in Newberry County. There I stopped at the P&D Old Country Store & Market. P&D, I presume, stands for Patty and Doug. Just outside the back entrance is a handmade sign: "PD's Produce and Firewood."

Inside I met Patty Dale, a friendly lady. "This store keep you pretty busy?" I asked.

"Gives me something to do." Patty sells jewelry here that she makes. You will find tomatoes, onions and bananas here too. Dolls and stuffed animals. Jams and art. Canned goods and spaghetti sauce. Lots of things. Consider it a general store. Nearby an old wood stove awaited winter.

"How do I find Tiny Town?"

"Drive on down 34 and look for a white house on the left," said Patty.

"Ok," I said, wondering just how many white houses might be on the left. "How do I know if I've gone too far?"

"You'll end up in Chappells," she said. Chappells, I knew, was a thriving town in Newberry County during the late 1880s before a tornado, flood and economic downturn doomed it.

Patty and I chatted a while as her infant granddaughter watched us. I shared a memory of when a friend and I stopped for barbecue chicken in Silverstreet a few years back. A couple of guys were selling it. We got a plate and chicken. That was it. No utensils. No napkins. Not even a paper towel. We ate with our hands like savages. When we were done, we washed our hands beneath a faucet at the fire station across the street. "That sounds about right," said Patty.

I said goodbye to Patty, and off I went looking for a white house on the left with a little western town behind it. Larry Newman and his family built it, starting back in 1991. Tiny Town features a Bureau of Indian Affairs, a general store, a chapel, a bank, a jail, a livery stable, an outhouse (that essential building) and more.

ABOVE Patty Dale of P&D Old Country Store & Market.

OPPOSITE TOP Tiny Town's chapel opens its tiny doors to reveal tiny pews and more.

OPPOSITE BOTTOM On Highway 10 in Verdery, an old store awaits its fate. To be razed or not?

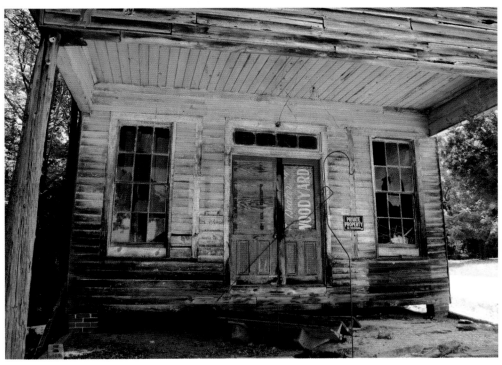

I found it about halfway between Silverstreet and Chappells. Would have missed it had I not spotted an old hay rake out front of a white house on the left of Highway 34. Glancing back, I saw a cluster of small buildings behind a house. I turned around on Green Acres Road and headed back to Tiny Town. Newman and his family's hard-but-fun work resurrects memories of old westerns. I half expected to see the Outlaw Josey Wales ride up.

I headed to Chappells. By the time I caught sixth gear, something told me it would not be easy finding Promised Land. It wasn't. I needed a route to the elusive Highway 10. In Ninety Six, I pulled up to a service station where two fellows were gassing up a big truck with a huge boat tethered to it.

"You fellows must be local. Going out on the lake?"

"Yep. Nope. Just trying to get the boat to run."

"Can you direct me to Promised Land," I asked.

One fellow hemmed and hawed a bit until his younger cohort came to his rescue. "Yes, take a left before that Hardees right yonder and just keep driving straight. Go about ten miles."

I did and wound up nowhere. My old map rescued me. Back into and then out of Ninety Six, I drove where I found Highway 221, which led to Highway 10, which I shot by, missing a right-hand hairpin turn. I turned around and made my way to a place called Verdery, a spot in the road but a beautiful spot. There I came across a magnificent old store that begged to be photographed. I got out to look around. Soon, I heard a dieseling truck headed my way. A fellow pulled up and asked me what I was doing. Turns out the store had long been in his family.

"Just taking photos of this old store…you don't mind do you?"

He thought and frowned a bit. A decision was being reached. "It's ok." As his truck's diesel engine rattled, he told me the store had been built around 1870, making it close to 150 years old. Said he had thought about tearing it down but was afraid the roof might collapse on him. On the side of the building was a beauty of a 7-Up sign.

"Tell me about Promised Land," I said, which was just up the road.

"Promised Land got its name from a promise a man made to give his slaves land. Sure enough, when he died, he did. That was before the Civil War—most unusual back then, you know."

The fellow drove off, and I took a few more photos. In a few miles, I would land in Promised Land and accomplish my mission. I made it to Promised Land and shot through it before I could hit the brakes. I saw a few homes, a church and a convenience store. Maybe 550 people call it home? With its biblical name, it seemed fitting that I parked beneath a shade tree in

the parking lot of the Cross Road Baptist Church. The marquee out front said, "God desires unity among believers." Earlier, I couldn't help but notice all the churches I had passed. All had marquees with messages designed to make me a better man. Truly I was headed in the right direction.

I continued my journey, ending in my native state of Georgia for the evening, and the next morning, using that real map, I plotted a drive up along the Savannah River, where I would work my way to an old bridge that crossed a rare free-running stretch of river. Yes, you can still find a stretch of free river between Lakes Hartwell and Russell. Not all of the mighty Savannah has been tamed. I had crossed that bridge a good many years back and yearned to cross it again.

The first road I took did not lead me to the old bridge. I crossed the Savannah River on Highway 184, where I took a left onto a highway of the old days, Highway 187. It was on this highway that I watched a big black snake slide across the pavement. Then, just like that, the snake vanished... 'twas only a mirage. I did not find my bridge, but I did come by an old

ABOVE The old store's 7-Up sign brings to mind *American Pickers* and its penchant for vintage evidence of older days.

abandoned grocery, Simpson Grocery. I thought of Homer Simpson, and when I turned onto nearby Highway 181 and spotted the Shady lady Saloon, I realized why Homer's grocery had not survived. Doh! A mural of "ladies" sitting on a pool table distracted him. Curvaceous and enticing, they looked like Amazons about to pose for *Playboy* magazine.

Continuing on Highway 181, I found the bridge I had crossed years earlier, a bridge of the old days. Neither you nor I will ever cross that bridge again. Its South Carolina terminus has been cut away. It hangs over the river,

TOP Highway 187 near the Georgia border. An old grocery store with homemade "security" bars across a window.

BOTTOM Wall art and shady ladies with voluminous hair evocative of the 1980s.

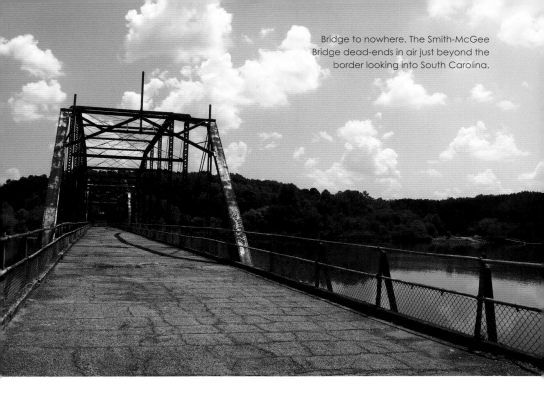

a dropping-off point if ever there were one. A wide concrete bridge, which seems to be the trend now, has replaced it. Barriers prevent you from driving onto the old bridge. Drive across this bridge and you essentially walk the plank, with a plunge into the Savannah River your fate.

Randomly taking back roads, one of the great joys of driving, set me on a course back home. Along the way, I spotted an old racecar, no. 14, parked on top of a small building. You could say unusual sights like this one elevate back roads above interstates.

You know you're on a back road when you spot log trucks, weedy overgrown road signs, big round bales of hay, radiant red and yellow canna lilies in yards and old chinaberry trees hovering over collapsed homes. Maybe science or a forestry expert can explain why chinaberries spring up around abandoned buildings. I see them all the time, always shading old timbers, stones and ruins of forsaken buildings. You also know you're on a back road when you come across hand-lettered signs, "Firewood for Sale" and "No Trespassing" signs. "You WILL be prosecuted!" You're certain you're on a back road when you pass a dirt road winding between deep green cornfields.

The car's thermometer hovered around ninety-eight degrees. Even on a steamy day, it's a joy to drive the back roads. I took Highway 702 along the western edge of Lake Greenwood and made my way back to Highway 34,

where my adventures had begun the day before. Time to head home with yet another back road excursion in the rearview mirror. And the claim that, yes, hallelujah, I've been to Promised Land.

The day after I returned home, I got an e-mail from Patty Dale of the P&D Old Country Store & Market. She sounded a lament all too familiar as little towns in the hinterlands go: "Thanks for stopping by, showing an interest in our little town and in our store. My Grandmother was born in this little town right in the house next door. Her father moved them into a house right beside the railroad track when she was six months old. She is 99 and lives in that home today. I wish things were like they were when she was growing up. The town was thriving. You know how things go in these small towns, as the other towns around you grow…they soon die."

She's right. Even Promised Lands endure adversity.

FOLLOW THE
RED-SHOULDERED HAWK

A<small>T</small> 8:00 A.M. on a balmy winter day, I strike out from Irmo. Destination? Dargan Farms, close by Darlington. Some one hundred miles later, I'm near my journey's end. When I turn off Pocket Road onto South Charleston Road, that flat old sea bottom, level-as-a-pool-table, sports fields that run 'til a line of distant woods halts 'em.

South Charleston Road? It just feels different. Oak allées line driveways, and naked, winter-stripped crepe myrtles flank the road. White fences run straight and true, and I better understand it later, for Edwin Dargan will tell me, "A lot of farm families live along South Charleston. We had it designated a scenic highway."

Edwin Dargan appreciates pretty places. I met him in Georgetown County in the fall of 2017 at beautiful Hobcaw Barony, Bernard M. Baruch's sixteen-thousand-acre retreat where Franklin D. Roosevelt and Winston Churchill encamped to plan D-day. We dined beneath oaks at Bellefield stables on corn-fed Nebraska mallards as Frank Beckham—hunter, fisher, chef, conservationist and raconteur—regaled geographically diverse folks with stories of the Southland. "I know you Yankees think we are just a bunch of grits-drooling rednecks, but we won't eat you." All said in jest, of course.

Dargan and I talked serious stuff. About how his family had long held farmland in Darlington County. How long? Prior to the Revolutionary War. Dargan even plowed with a mule. That did it. I knew a good story was to be had, so here I am driving down South Charleston Road to see Edwin. The day is especially warm compared to the recent cold spell that gripped the land, but the promise of spring fills the air and an appreciative chestnut

mare rolls and kicks its hooves as I drive by. As I turn onto the driveway to Dargan Farms, a red-shouldered hawk glides straight down its middle. That hawk guides me toward a surprising and important scene, as you'll see.

Across a big field, a long center-pivot irrigation machine idles the time away against a line of gray, leafless trees. Winter is a bleak time around farms, when nothing much seems to happen, but of course it does. Cirrus clouds feather a blue sky white as I park by the red-and-white steel building that headquarters Dargan Turf Farm. The Dargans grow centipede, Bermuda and zoysia. "We used to grow St. Augustine, but winter gave it a hard time," said Dargan. "We're about 60 percent sod and 40 percent row crops. Row crops is tough going." He pauses. "Farming is a good life, but it's a tough way to make a living because you got to depend on the weather."

It is tough. Dargan knows it's important to take care of the land, and he believes most farmers feel the same. After all, land that supports farming families today must support their heirs into the future. Dargan backs his belief—he put some of his land in the Pee Dee Land Trust, whose mission is to conserve and promote an appreciation of the significant natural, agricultural and historical resources of the Pee Dee region.

Conservation-minded farming's long been a family affair with the Dargans. Death by influenza cut short Edwin's grandfather's farming at the age of thirty-three. Edwin's father, however, William Edwin Dargan Sr., had a long run. He graduated from Clemson University in 1934 and served in the United States Army from 1942 to 1947 as a World War II captain. He took part in Roosevelt and Churchill's invasion of France and Germany. After that, he farmed the family land for half a century. He took care to conserve the land and water, implementing no-till farming, wildlife buffer zones and other conservation measures the family still employs. William Edwin Dargan passed away in 2006, but his legacy continues with Dargan and his son, Ned, who make up the fifth and sixth generations of Dargan Farms Partnership. And now William "Edwin" Dargan, Dargan's grandson, makes the seventh generation to work the land. It does my southern heart good to see family land remain family land.

And that red-shouldered hawk? It guided me in between a children's playground on the left and a pick 'em strawberry patch on the right, a patch snoozing beneath white plastic, which looked like snow. Those red and green strawberries? Well, some might end up at South of Pearl, a restaurant in Darlington. Make a note to enjoy some on South of Pearl's reclaimed wood table. It's used to colorful things, having been a paint counter at an old hardware store.

Nowadays, farming means being open to change. Several years ago, Dargan added agritourism to his operation. He cut a maze into his corn and set up an area where kids have fun and see the farming life up close. Think of these attractions as "agtivity" areas, a playground complete with a concession stand and gem "mine." There's a place to play king of the mountain and a swing set, and in the midst of it all stands a handsome tobacco barn, a reminder of South Carolina's farming heritage.

One year, Dargan Farms shaped its corn maze like a beehive to emphasize the honeybee's importance to farmers. A large round hay bale made to look like a giant spider greeted kids at the maze. Come spring, none other than the Easter Bunny hopped down the bunny trail to join children in the pick 'em strawberry patch, where they learn that food doesn't come from Publix. Getting kids up to speed about farming is important, and adults can use some help too. "A lot of adults can't tell soybeans from cotton when they see them growing," said Dargan.

Come fall, the corn maze bemuses and befuddles kids and a few adults as well. Such amusements are more than amusements, though. Kids learn what a farm is all about while having fun. Edwin Dargan has fun as well. Each morning, he walks the farm with his son's dog, Deke. And the kids? Some might grow into adults who can tell cotton from soybeans in the early stages. And some might even grow up to be conservation-minded farmers in the Pee Dee, where country roads lead to the fields that sustain us.

See for yourself. Drive to where the land flattens out and scan the sky. When you spy a red-shouldered hawk, follow it. Hawks know that where there's a farm, there's life.

VANISHING TENANT HOMES

THEY STILL STAND, but nowhere as many as once did. And the ones I see? Well, they are in a sad state. The back roads are surely losing an attractive part of the past. I'm talking about tenant homes, those stately little shacks that provide one last glimpse of a vanquished culture.

As a boy, I used to see them everywhere. Elegant little houses resting on rock piles standing like sentinels over fields. Now they are rare, although a drive into farm country still turns one up now and then. I came across one near Cameron on Highway 176. Morning mists, like the mists of time, swirled around it. Something about the fog—which it was, to be truthful—made the old ruin even more handsome. A mat of pine straw miraculously clung to its rusty tin overhang. The home itself, with one of its two windows shuttered, looked blind in one eye. It rendered the stretch of Highway 176 glorious.

Referred to as saltbox houses, catslides and pole cabins, tenant homes long stood with grace and character in pastures and fields. In their heyday, a sea of white cotton surrounded tenant homes every summer, but when the mules, plows and hoes gave way to tractors, the homes were abandoned. Today, nothing but wasps, mice and birds make their homes in them. Weather, vandalism and sheer neglect have long been destroying them, and today few remain. All that's left of many are chimneys, a pile of bricks and field stones.

For generations, the plain folk of the South lived in tenant homes. Many sprang up during Reconstruction, an era of suffering and upheaval when being a tenant farmer meant a step up the social ladder. Sharecroppers exchanged a crop for a house and a share of the yield. Still, a tenant farmer

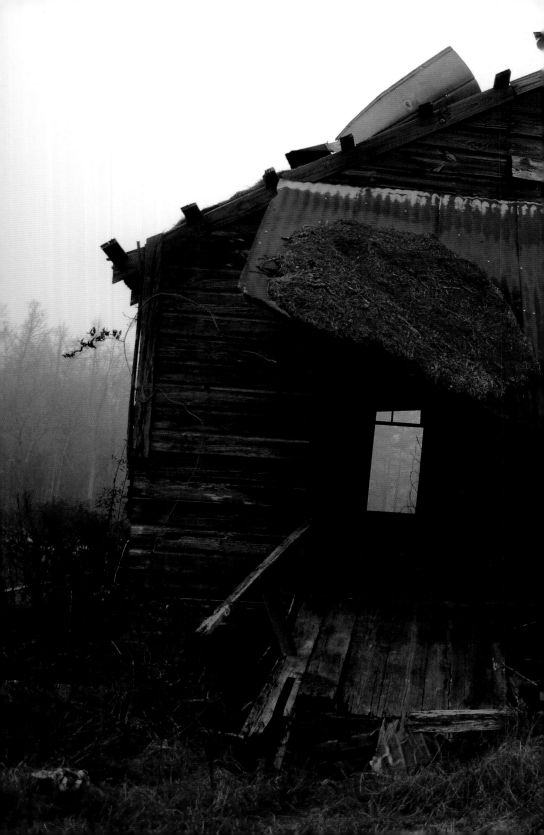

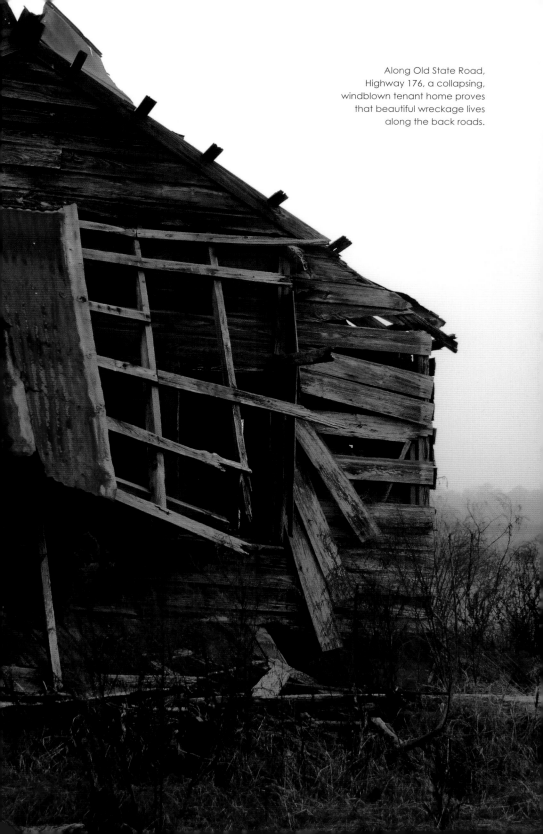

Along Old State Road, Highway 176, a collapsing, windblown tenant home proves that beautiful wreckage lives along the back roads.

often had nothing to show for his efforts at year's end. I came across a tenant home that was succumbing to nature. Trees and vines covered it. I wrote about it, and people who knew the owner contacted me. The owner lived in Nashville, and I called her.

As I suspected, her little tenant home had a colorful history. Part of its history is told in *The Miracle of a Friendship*, an autobiography written by her late father, James Robert Colvin, known as J.R. "A young black man came to work for my Daddy in 1930. John was probably 18 or 19 at that time....John Bennett was one of the two black men I loved like a brother."

John Bennett was the only person who lived in the little tenant home built by J.R.'s dad. Inside, shelves once hung to store John Bennett's glasses, dishes, pots and pans. A table with two chairs and a bed were there too.

J.R. wrote, "John kept his house spotlessly clean. His yards were well kept, and he usually had blooming flowers and shrubbery he would obtain from his mother. John could do anything! He was not a big man, but for his height and weight he was as strong as any person I've ever known. He and I would go fishing together, go hunting together or would sit by his fireplace during cold, rainy days and play checkers by the hours....We loved and respected each other as if we were brothers."

All tenant homes have histories, but alas, we cannot so easily know them. Look around your home and consider that tenant homes had no plumbing, no built-in sinks, no cabinets and no closets. Generally, only functional furniture such as pie safes, beds and chairs graced these old homes. Jars and simple containers on crude shelves held staples like cornmeal, flour and grits. Kerosene lamps broke the darkness. Buckets hauled water up from wells. Life was hard except tenants didn't know it. They gathered in the evening to swap stories and sing. There was no TV, no radio, and maybe that was a blessing in a way. *Survivor* was not a TV show but a way of life, and everyone pulled together.

And then change arrived. Southern farm tenancy ended abruptly after World War II. Government programs, farm mechanization and tenants' own inefficiency drove them from the land, and the seductive call of prosperity lured them to the city. After decades of painting them, patching them and sealing cracks in the walls with newspapers, people have long left tenant homes alone, and that is sealing their fate.

There's more beauty in a weathered tenant home than a sparkling new vinyl-sided house. Tenant homes' simple architecture distinguishes them. And where best to find them? Along a sleepy byway, a road where an old tenant home does its best to stand against the wind. And the ceaseless winds of change.

SOJOURN INTO SPANISH MOSS COUNTRY AND BEYOND

O N THE WAY to a family vacation on Tybee Island, I took Highway 21 south toward Lowcountry back roads while arranging my day to end in Beaufort. I was looking for great stories in the land of Spanish moss, and I found a few. Anytime I am near Yemassee (just saying that word is a pleasure), I go to Sheldon Ruins right away. This trip was different. Before going to Sheldon Ruins—Prince William Parrish Church once upon a time—I intended to stop at Harold's Country Club, a place I've long longed to visit.

A COUNTRY CLUB LIKE NO OTHER

Harold's Country Club proclaims that it is "in the middle of nowhere but close to everywhere." That's true. You'll find it off Highway 21 at 97 Highway, 17A. I did when I pulled up in front of a sign that's seen its share of Lowcountry sunlight, sayeth its faded, yellowed plastic. Nonetheless it's colorful. A grill full of ribs, chicken and a huge steak fill one side, a frosty mug of beer the other. In the middle is a graphic: a circle around a bespectacled Harold and the words, "Harold's Country Club…Bar & Grille, Est. 1973." The likeness of Harold Peeples makes the sign. He looks like a sheriff from a tough county in south Georgia. He looks a bit like another famous Harold, Harold Bessent of Ocean Drive fame.

POOL ROOM RULES

NO DRINKS OR FOOD ON POOL TABLES

NO SMOKING

NO SLAMMING TABLES

NO HITING STICKS ON TABLES

NO SITTING ON POOL TABLES

follow the rules or you willbe barred from playing pool o

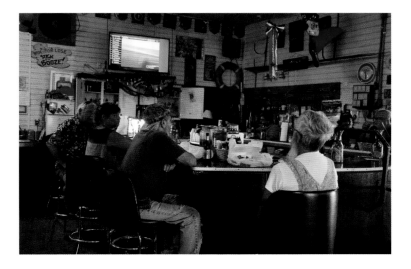

I took stock of the place. At the right, front corner of the building stands an old Fire Chief gas pump. Gives the place character. I walked up to the front glass door with a sky blue paper note stuck to the glass: "Benton's Fresh Boiled Peanuts." Yep, you could smell salt in the air.

Over between the restrooms, a digital jukebox, TouchTunes, sat idle. Nearby, two dispensers of paper towels sat on a camouflage-covered table. I suspect come October's cool blue evenings, fluorescent orange deer hunters love this eatery off the beaten path.

Rules caught my eye. "You are required to pay for every steak you order." "Please clear table." In the billiard area—excuse me, pool room—a list served notice that improper behavior would not be tolerated. A few admonitions: "No Smoking." "No Hitting Sticks on Tables." "No Sitting on Pool Tables." And then, in lowercase, "follow the rules or you will be barred from playing pool." Over near the bar, some advice: "Win or lose, stick with booze."

Locals heeded that advice. Even at 3:30 p.m., a cast of characters sits around the bar. "Like a scene from Andy of Mayberry," I mused. Harold's has to be an oasis to locals. Yemassee is twenty-one miles from Beaufort as the crow flies, eighteen from Walterboro. On the flatscreen at the end of the bar, a NASCAR race was underway. A black-and-white car flirted with the wall. No one paid it any mind. At the bar's opposite end, a giant plastic parrot on a perch watched the race. Well, it appeared to.

A boy wearing a red-and-black athletic shirt, no. 15, sat at the bar. I consider Harold's a family-friendly place. That doesn't preclude a movie poster in the pool room that features a scantily clad woman with a pair of fabulous legs. The gams promote *Bordello of Blood*, "Where customers come in, but they don't come out."

Well, no worries, you'll come out of Harold's Country Club in good shape, but know that when you walk in you are stepping in high cotton. A touch of fame attends this venerable old way station. Celebrities and celebrity makers have been here. Harold left us in 2003, but in his day, he had a special friendship with movie mogul Joel Silver, who owns nearby Auldbrass

OPPOSITE TOP A country club like no other. A restaurant like no other. In Yemassee, where an old Chevy dealership evolved into a legendary eatery. Famous for steaks.

OPPOSITE MIDDLE Obey Harold's rules or your game of eight ball won't last long.

OPPOSITE BOTTOM Harold's bar. The gathering place, like a scene from a movie. Win or lose, stick with booze.

Plantation of Frank Lloyd Wright fame. Joel often stopped by on Sundays to have coffee with Harold.

In 1994, Dennis Hopper transformed Harold's into a biker's bar for his movie *Chasers*. The print world loves the place, too. *Coastal Living*, *Esquire* and *Southern Living* magazines have all covered Harold's. *Garden & Gun* called it one of the best dive bars in the South. So dive right in.

How did all this come about? Permit me a bit of history—backstory, you could say. The family-run business was long a gathering place for the community. What would become Harold's Country Cub began in the 1930s as a Chevrolet dealership. Harold Peeples bought what had become an old-fashioned garage and gas station in 1973. In the late 1970s, friends and neighbors began a beautiful custom: gathering for covered dish suppers on Thursday nights. Over time, the group began cooking and eating in the garage to avoid bad weather and the gnats and mosquitoes for which the Lowcountry is famed. As Thursday evening gatherings grew, Harold took over the cooking, charging a small amount to cover expenses. In time, Friday wings and things and Saturday steaks joined the menu.

Today, every Thursday features a different meal. Fridays you can enjoy wings and things, seafood, chicken, steaks and hamburger baskets, as well as extras such as jalapeño poppers, fries, fried mushrooms, hush puppies, onion rings and more. Saturday nights usher in steaks, twelve- to fourteen-ounce choice cut rib eyes. Meals include a baked potato, sautéed onions, a salad and a roll. Again, dive right in.

When the back roads lead you to Harold's, your destination is a car place that became an eatery. It's a tale worth telling, this evolutionary story of cars yielding to growling stomachs beset with hunger pangs. In earlier days, folks moved cars out of the garage to set up tables and chairs. In time, the cars left for good—parking places elsewhere. What was the garage's lube rack is now a "stage" seating area commandeered at times for live music. (Harold built that stage over the "grease rack" in lieu of removing it. How cool it'd be to watch that rack rise with a country band on stage, giving them a platform like no other.)

As the garage evolved into a bar and restaurant, radiator hoses and fan belts stayed put. Gave the walls atmosphere. On May 9, 1999, a big fire changed that, destroying the entire bar area, hoses, belts and all. Though under-insured, Harold rebuilt. Friends donated various artifacts to help restore the unique décor. A room for extra seating and private parties morphed into the bar, and Harold's was up and running within a week, although it would be two weeks before meals could be prepared. Missing

the first Thursday potluck was too much. Several customers asked Harold if they could bring covered dishes so everyone could share a meal. The food was back, and the rest, as they say, is history.

But wait. Hold on. We have one more fish to fry. What about that name, Harold's Country Club? Well, a tale's behind that too. Because all work and no play make Harold a dull boy, he devoted much of his time to baseball and softball. He played, coached, umpired and supported the local softball team. When that team lost its field and needed a place to play, Harold and friends formed the Yemassee Athletic Association. They bought land and built a ball field across the road beside what today is the Country Club, known then as Peeples Service Station.

After the games ended, announcer Charles Jackson had a custom of sorts, saying, "Now, let's all go over to Harold's Country Club for a cool one." Soon people started calling the business Harold's Country Club.

I would have liked Harold. Despite all his rules, the man had a heart. Rich or poor, he treated folks the same. He had a reputation for helping people—friends, strangers, stranded motorists, whoever needed a helping hand. He valued good times and wanted everyone to have just that. But then there were all those rules. He didn't accommodate tomfoolery. In fact, he banned troublemakers from his old Chevy dealership "for life and a day."

For life and a day. Folks, that sounds a lot like forever. Well, it just sounds like it because it wasn't quite true. A sincere apology got them back through the door, resurrecting their membership. And you know and I know they had to be grateful. Grateful to be reinstated at Harold's Country Club down yonder in the middle of nowhere, where breezes stream Spanish moss back like an older woman's tresses and old oaks tremble when winds press against limbs heavy with resurrection ferns. Down yonder in Spanish moss land, where a Saturday night carries the aroma of grilling steaks and locals talk about movie stars, old cars and rules. Lots of rules.

EVOCATIVE RUINS

Rome doesn't have that much on the South, which has its own beautiful ruins. Down in Yemassee on Sheldon Church Road stand old ruins that are as good as most Roman ruins—the remnants of Old Sheldon Church itself. Massive walls flanked by giant columns and a spacious interior attract photographers from all over. Majestic oaks and ancient graves surround the

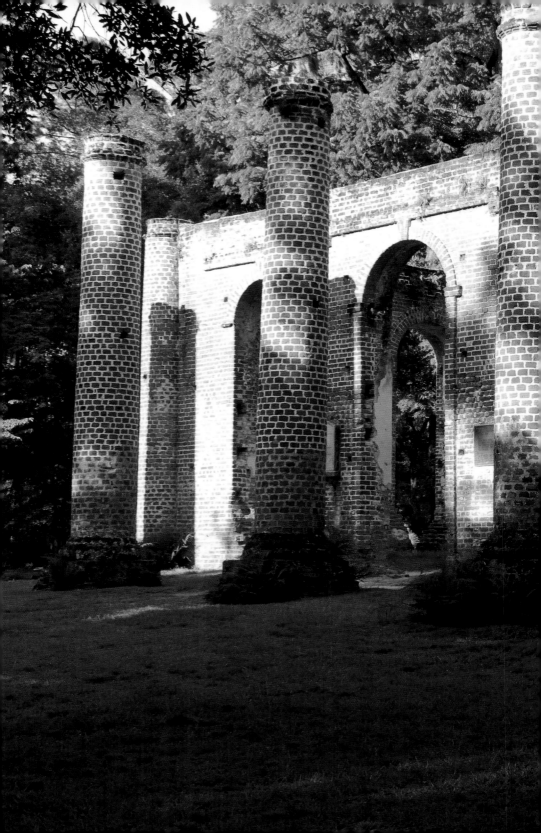

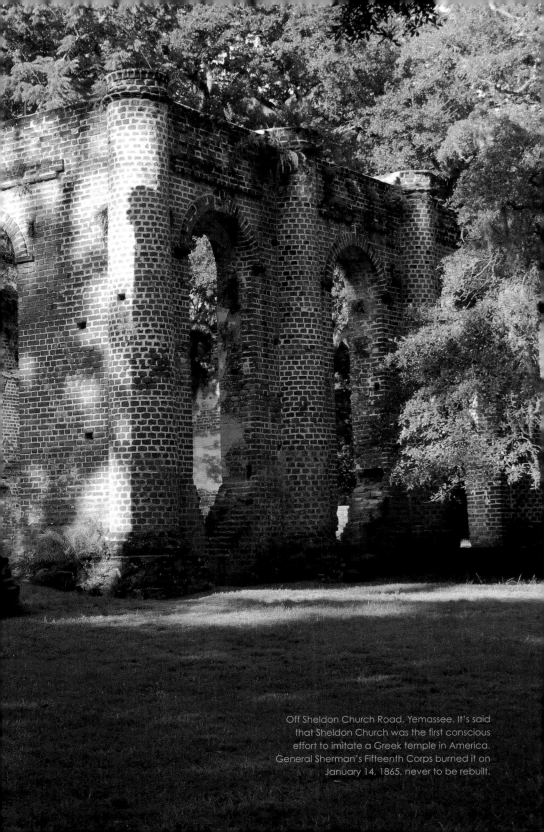

Off Sheldon Church Road, Yemassee. It's said that Sheldon Church was the first conscious effort to imitate a Greek temple in America. General Sherman's Fifteenth Corps burned it on January 14, 1865, never to be rebuilt.

ruins. It's moving to walk the grounds and imagine all that transpired here. Evocative, the ruins are one of South Carolina's more legendary settings.

You'll find the ruins near Yemassee, which takes its name from the Yemassee Indians. The town is small in size but big in history, and much of that history involved war. As the Civil War wound down, Sherman came through Yemassee on his infamous March to the Sea. You'd think places of worship would have been spared, but that wasn't the case. Sherman destroyed all churches in the area except for the Presbyterian church, which the Union army used as a hospital.

Old Sheldon Church, once known as Prince William Parish Church, has been bedeviled by war. Back in the Revolutionary War, Continental troops drilled on church grounds, and Patriots are believed to have stored gunpowder in the church—justification enough for British General Augustine Prevost's troops to torch the church in May 1779. The church was rebuilt from its remaining walls in 1826.

Thirty-nine years later, General Sherman's Fifteenth Corps under General John Logan burned the church on January 14, 1865. A letter, however, says that Sherman *didn't* torch the church. After the Civil War, one Milton Leverett wrote, "Sheldon Church not burn't. Just torn up in the inside, but can be repaired." Whoever or whatever savaged the church failed to totally destroy it. Once again the walls refused to fall. One account says area residents gutted the church to rebuild their homes burned by Sherman. No one bothered to rebuild the church this time, thus do the hauntingly beautiful ruins remain, gracing the National Register of Historic Places.

Classic in their simplicity, old brick columns stand as monuments to Prince William Parish Church. Built in 1745–55, it's one of the country's first Greek Revival structures. You can still see part of Sheldon Church's old gate, and an old hand-operated pump near the gate still works. Inside the ruins rest the remains of Colonel William Bull, who helped General Oglethorpe select Savannah's location and layout. If only these old walls could talk.

Dust to dust. Long after we're gone, these ruins, like ancient Rome's, will carry on, causing the curious, writers and photographers to marvel at once was. It's well worth the drive, and Old Sheldon Church Road itself is a trip through time to the South of old.

OPPOSITE On Highway 321. Is this old store waiting on crowbars and hammers? Check out the old screen door.

NORTH TO AIKEN

After a night in Beaufort, I headed over to Tybee Island. The week sped by, and Saturday morning, when we all said goodbye, taking rural routes to a book event in Aiken was an easy decision.

Through the heart of lovely historic Savannah, I drove to Highway 17 North to the Talmadge Memorial Bridge, which spirited me into Carolina. I had plotted a route down 17 to 321, then peeling off onto 278 and ultimately to Highway 19, which took me by the University of Georgia Ecology Lab Conference Center and through New Ellenton into Aiken.

Highway 321 proved to be a bit disappointing as back roads go. For the most part, it was a corridor amid green walls of trees. Once, however, I passed what I am sure is a Carolina bay, a legendary elliptical landform that science has yet to prove what created it.

Along the way, I came across yet another abandoned store. They're everywhere. When I got out to photograph it, a wiry, tan fellow left the pickup engine he was working on and sauntered over. He looked at me with curiosity, cocking his head as a dog does.

"Mind if I photograph your store?" I asked.

"Might as well. The beautification committee wants me to tear it down," he said.

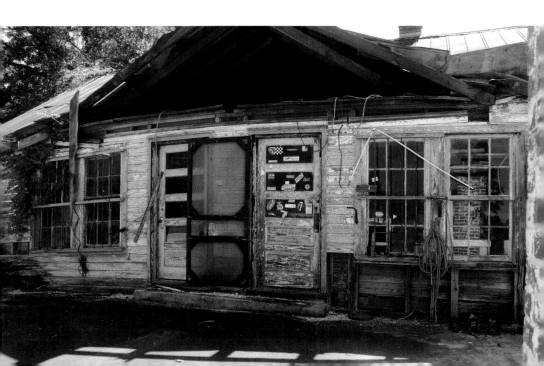

"I think it's beautiful."

"Well, tell that to the committee," he said. "I told 'em, 'You want it tore down? Get some crowbars and hammers and have at it.'"

It's junky, but something about the store evoked beauty, a glimpse into the past. Why tear it down? It'll collapse one day.

As I drove through Estill, my days teaching at Columbia College came back to me. I taught a girl from Estill all those years ago. Can't remember her name, but I recall she would send a bouquet of roses to herself each Friday

ABOVE In Allendale, a predecessor to modern water tanks. One of three standpipes in South Carolina. The other two are in Belton and Walterboro.

when her boyfriend came to visit her. She left the roses at the front desk to make him think another fellow was interested in her. The goal? Marriage. It worked, but I have no idea what became of her or him. The realist in me says divorced. Maybe not, though. Some folks actually like being married.

Rolling into Allendale, I recalled a friend from a lifetime ago. He had worked there as a pharmacist. Then changes set in. The upshot was that he vanished into a hermit-like life.

It was in Allendale, too, just off 278, where I saw a strange tower, a standpipe, one of three in South Carolina. Circa 1915, it's a predecessor to today's water tanks. Trust me when I say you don't see standpipes every day. Imagine the biggest silo you've ever seen and multiply that by a factor of five.

After a hasty, tasty detour for barbecue in Barnwell, I hit the road for Aiken. No more stopping. I arrived at the event ten minutes late. After it ended, I broke my "no interstates" rule and drove home on I-20. I had been up since 5:45 a.m. to photograph sunrise at Tybee Island, and I just wanted to get home. I had been gone nine days on a trip that took me onto Beaufort's back roads and ended in Irmo, with eight days in Georgia in between—a true Georgialina adventure. Unpacking my bags, folded neatly, there they lay. Family and back road memories.

LIKE GOING TO AFRICA

IN WILLISTON, SOUTH CAROLINA, on Highway 78 near SC 781, you'll spot a small lane that leads to Ditch Pond Heritage Preserve. Ditch Pond, as it's called, is a Carolina bay that takes its name from ditches that attempted to drain the bay. Despite the ditches, Ditch Pond is relatively undisturbed, a rarity as Carolina bays go. And as many Carolina bays go, it's a rich repository of wildlife and vegetation.

I went there one late April day. Although I was closer to the Piedmont than the Lowcountry, Ditch Pond gave me the feeling I was down near Beaufort or Charleston. A short walk from the entrance, I found myself in an alleyway of large oaks and Spanish moss. Skeins of Spanish moss hung long and majestically, and late afternoon light lit them up as if on fire.

I made my way to the boardwalk that extends into the bay's open area, and here the sunlight slanted low against a distant edge of trees with light bark and willowy canopies. Between that faraway edge and me, gallinules hopscotched across lily pads and herons stalked the shallows as braces of ducks jetted overhead. To the far left of the end of the boardwalk, a patch of blooms the color of margarine broke the greenery. Must have been blooming bladderworts. The sunlight, fading from its all-day travels, yielded a soft, incandescent glow to everything, and the cumulative effect seduced me into thinking, "Beautiful and wild like Africa, just like Africa." I half expected to hear a herd of wild beasts thundering to the water edge only to blunder into an ambush by big crocs.

The author looks across Ditch Pond, a Carolina bay and Heritage Preserve located between Highway 78 and Aiken Road in Aiken and Barnwell Counties. *Photo by Robert C. Clark.*

Ditch Pond sits in Aiken and Barnwell Counties. The South Carolina Department of Natural Resources owns and maintains Ditch Pond Heritage Preserve, some 296 acres. Ditch Pond, about 25 acres, was first documented in 1973 as a Carolina bay. Eight rare plant species of concern inhabit the property, including blue maidencane, Robbin's spikerush, creeping St. John's wort, piedmont water milfoil, awned meadow beauty, slender arrowhead, Florida bladderwort and piedmont bladderwort.

Be sure to take a camera. Find a good spot to sit and be still. Wait to see what creatures venture forth. If you go, I hope your luck is as good as mine. Just before leaving—it was getting dark—I walked over to photograph the DNR signs. Glancing across the sandy parking lot, I spotted a crumpled green wad of paper—a five-dollar bill. You see, it pays to go to places off the beaten path.

DOWN BY THE
CATAWBA RIVER

DRIVING NORTH ON US 21 toward a "very small town," I watch the land change. Hills rise into view. Large rocks protrude from the ground. Boulders. I'm passing over the land where hard crystalline basement rock meets softer sedimentary rock. In plain English, I'm leaving the coastal plain for the piedmont. The junction of these two zones creates the Fall Line. Great Falls sits on it, and I'm headed that way.

I drove around and through Great Falls several times, that town down by the Catawba River. The day was cloudy and gray, and I sensed ghosts. When I saw an old brick building with an old wall dog sign on it, I knew ghosts were about, sure enough. At first, it looked like the old sign spelled "Pelks," but I knew in a flash that once upon a time Belks operated here. As I took photos, I saw a big man walking toward me.

"Can I help you?"

"Just taking photos," I said, and we began the business of feeling each other out. Turns out that Glenn Smith and I had a connection with the University of South Carolina's Media Arts Department back in the 1980s. We tossed familiar names about. Glenn had worked there, and I had often freelanced for the various project directors, people like Larry Cameron.

Glenn said that before Belks came along, the old brick building had been a company store. Textile workers spent company scrip for goods there. As a result, Great Falls developed a split personality. Back then, private merchant Andy Morrison, who had a drooping eyelid, sold things people needed at lower prices. The company discouraged its workers from trading with old

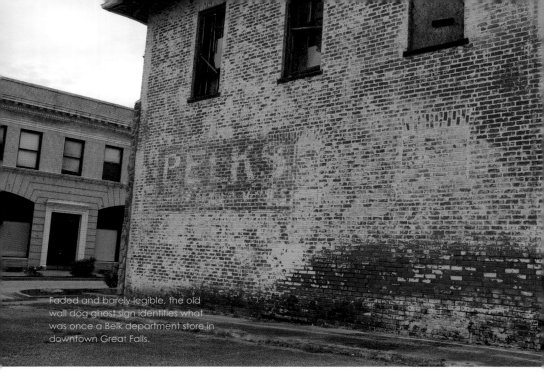

Faded and barely legible, the old wall dog ghost sign identifies what was once a Belk department store in downtown Great Falls.

Flopeye, but people liked his prices and genuinely liked him. As a result, the area around the Number 1 mill, company store, bank and First Baptist Church came to be known as "Downtown," while the retail area where Flopeye held court came to be called "Flopeye." To this day, two business areas exist.

In their heyday, textile companies dominated workers' lives, but people at least had jobs, something in short supply, but the devil Change would make those go away. I drove on and saw something that spoke volumes: a rusting, bent turnstile that stood at the entrance of a textile mill. Vines had woven through the chain link fence attached to the turnstile. I imagined that turnstile in better days, shiny, well maintained and turning smoothly as a long line of workers filed in to work their shift. Now it rusts. Some would say decays. A short drive away, a similar turnstile awaited workers who would never return. Rust-frozen turnstiles, icons of economic downturn.

Great Falls was once a mill town, and like other mill towns, it has a tortured history. It was first known as Catawba Falls and was a boomtown in the early 1900s. Sitting on the old US 21 peddler's route from Charleston to the mountains of North Carolina and beyond, it was in a great spot. Tobacco baron J.B. Duke, who owned a power company you might've heard of, founded the town. J.B. had a propensity to build hydroelectric plants on

the Catawba River, which courses by the town's eastern edge, creating some serious rapids and, as you'd expect, great falls.

Those falls led J.B. to found three Republic Cotton Mills, which pulled people from the plow into newfangled jobs. It's a story I know, having written about it in *Transforming South Carolina's Destiny*, the history of South Carolina's technical college system: "Farming's mechanization, federal crop restrictions, and foreign competition in cotton and tobacco forced thousands of people off the farm. Farm work was just no good and millwork wasn't far behind. Textile mills began eliminating many jobs through automation. Cheap imported textiles closed mills and led to less demand for domestic cotton. There was one way out. Leave. Walter Edgar explained this exodus in *South Carolina: A History*, 'Changing agricultural patterns resulted in reduced job opportunities and were another factor in the depopulation of the countryside.'"

One fellow expressed this situation in a heartrending way: "My daddy was the strongest man I know, but not having work brought him to his knees."

People left farming communities to live in the newly constructed mill villages, where homes featured running water and electricity. Great Falls' mill villages still exist, and their homes are most curious. Large rocks—boulders, really—sit all around them. Some homes have no front yard, just miniature Stone Mountains, rocks bigger than cars. Well, less grass to cut.

The mill company also provided merchants new commercial buildings downtown. All that would go away too despite old Flopeye's efforts. You can witness the outcome in various ways. Up the street a short ways, a gas station of the old days sits idle. Green and white, its long overhang rests on just one column. Gas pumps are MIA, and the concrete lot is badly cracked. Here and there, grass slowly colonizes all that hardness.

When people leave, businesses close. In 1950, 3,533 people called Great Falls home. The ensuing decades brought a steady decline, and in 2016, it was estimated that 1,928 people lived in Great Falls. And no wonder: three mills had closed, as did the sewing rooms, and a spiral-down effect hurt retail services—a scenario that affected other areas such as the Glendale community up near Spartanburg. In the 1950s, as textile jobs declined, workers sang the blues as their way of life crumbled. The glory days were slipping away.

Smith, however, feels optimistic. The town's vintage look and the Catawba River could play roles in a resurgence based on tourism, and he may well be right, for down by the river there's an intriguing attraction: Stoney Lonesome, the old jail, which last saw inmates around 1951. The jail

was built circa 1912. In March 2011, former town councilman Larry Loflin helped town employees and community service workers unearth the old jail with a backhoe. Somehow it got covered when the first Republic Cotton Mill expanded its parking lot. Loflin said that the old jail is "a nice bit of chrome for the town, a forgotten piece of history."

You could say that old jail came back from the grave. You could say they dug up the past, and you'd be right. Why not? Travel the back roads and you ride into the past. Old mills, boulder-strewn yards and Stoney Lonesome make for a nostalgic destination where a river famed for Indian pottery watched a textile industry wash downstream.

I hope Smith is right. Maybe, just maybe, more people will be inclined to take US 21, 141, 97 and 200 to this handsome village down by the banks of the Catawba River. Maybe they'll want to see the past. Sure, Great Falls has some wreckage, but it's authentic—a real-deal place, nothing fake about it at all—and that's due in part to its location a ways off the interstate, the road to everywhere, the road to nowhere, the road to nothingness.

EPILOGUE

THE BEGINNING OF THE END began for many of South Carolina's fine two-lane highways on June 29, 1956. That's the day President Dwight Eisenhower signed the Federal-Aid Highway Act, the Interstate Act. Eisenhower, a general to the end, envisioned highways as "broad ribbons" laden with tanks and troops, and South Carolina got its share.

Over sixty years, five interstates and 757 freeway miles later, a grid of steel, cement and asphalt makes it possible to cross South Carolina and see little of anything other than interchanges, bridges, concrete barriers and orange safety barrels. And lots of trucks—at times it's like driving beside a train.

Don't despair. The real South Carolina is still out there. While it's true that interstates relegated once-busy highways to back road status, think of it as an act of preservation. The state's hidden beauty, history and mystery wait along forgotten byways and back roads.

With great patience, they wait for you and me.

INDEX

ABOUT THE AUTHOR

Tom's work has appeared in magazines throughout the South. Among his recent books are *Classic Carolina Road Trips from Columbia*; *Georgialina: A Southland, as We Knew It*; and *Reflections of South Carolina, Vol. 2*. Swamp Gravy, Georgia's Official Folk Life Drama, staged his play, *Solid Ground*. He writes a weekly column for newspapers and journals in Georgia and South Carolina about the South, its people, traditions, lifestyle and changing culture and speaks to groups across South Carolina and Georgia. Tom grew up in Lincoln County, Georgia, and graduated from the University of Georgia. He lives in Columbia, South Carolina, where he writes about "Georgialina"—his name for eastern Georgia and South Carolina.

Visit us at
www.historypress.net